KING UPON THAMES IN 50 BUILDINGS

JULIAN McCARTHY

amberley

About the Author

A qualified Kingston upon Thames tour guide and a founder member of The Maldens & Coombe Heritage Society, Julian's passion is searching for obscure or forgotten historical nuggets of Kingston and New Malden that he believes lie waiting to be found and brought to light and enjoyed by all. He is a treasure hunter where the treasure is the 'quirky' buried in old books and is a would-be detective and 'solver of the unsolved'. He was 'off school' the days they studied 'Brevity' and 'Curbed Enthusiasm'.

A Chartered Design Engineer and a Consultant by profession, he lives in New Malden. This is his second Amberley publication and follows *Secret Kingston upon Thames*.

For Brandon and Juliet

First published 2017

Amberley Publishing, The Hill, Stroud
Gloucestershire GL5 4EP

www.amberley-books.com

Copyright © Julian McCarthy, 2017

The right of Julian McCarthy to be identified as the Author of this work has been asserted in accordance with the Copyrights, Designs and Patents Act 1988.

Map contains Ordnance Survey data © Crown copyright and database right [2017]

All rights reserved. No part of this book may be reprinted or reproduced or utilised in any form or by any electronic, mechanical or other means, now known or hereafter invented, including photocopying and recording, or in any information storage or retrieval system, without the permission in writing from the Publishers.

British Library Cataloguing in Publication Data.
A catalogue record for this book is available from the British Library.

ISBN 978 1 4456 5648 9 (print)
ISBN 978 1 4456 5649 6 (ebook)

Origination by Amberley Publishing.
Printed in Great Britain.

Contents

Map	4
Key	5
Introduction	6
The 50 Buildings	8
References and Bibliography	93
Acknowledgements	96

Key

1. All Saints' Church
2. The Old Bridge Foundations
3. Clattern Bridge
4. The Lovekyn Chapel
5. The Wall by the Lovekyn Chapel
6. Conduit Houses, Coombe
7. Nos 5–9 Apple Market
8. Nos 37/41 High Street
9. No. 14 Market Place
10. No. 1 Thames Street
11. Nos 6/8/8a Church Street
12. Nos 2–2a Church Street
13. No. 30 Old London Road
14. Cleaves Almshouse, Nos 49–71 Old London Road
15. The Druid's Head, No. 3 Market Place
16. Picton House, No. 52 High Street
17. No. 17 High Street
18. Elmfield, No. 115 London Road
19. The Old Mill House, No. 79 Villiers Road
20. Nos 14/16 Church Street
21. No. 30 High Street
22. The 'New' Bridge
23. Market House
24. Church of St Raphael
25. Royal Cambridge Asylum Lodge, No. 41 Cambridge Road
26. No. 1 Market Place
27. Seething Wells Waterworks, Portsmouth Road
28. The Old Police Station, No. 22 Old London Road
29. The Second Workhouse Infirmary, Coombe Road
30. The Keep, King's Road
31. The Old Post Office, No. 42 Eden Street
32. 'Boots façade', Nos 15 and 16 Market Place
33. Surrey County Hall, Penrhyn Road
34. Nos 3 and 5 Thames Street
35. Gazebos
36. Kingston Public Library
37. Kingston Museum and Art Gallery
38. The Old Kingston Telephone Exchange, Ashdown Road
39. The Old Empire Theatre, Nos 153–61 Clarence Street
40. Sopwith House, Canbury Park Road
41. The Old Regal Cinema, Nos 22–30 Richmond Road
42. Bentall's Wood Street façade
43. Siddeley House, No. 50 Canbury Park Road
44. Guildhall
45. Bentall's Depository
46. Surbiton Station
47. John Lewis Store
48. The Bentall Centre
49. The Rotunda
50. The Rose Theatre

Introduction

The earliest date referring to Kingston is AD 838 when King Egbert of Wessex convened a 'Great Council' at what today is believed to have been a simple farm estate. Any buildings that were present at the time – dwellings, stables or even a place of worship – were all, undoubtedly, of timber construction and it is not surprising at all that none have survived. The passage of time, natural decay, and town development have each contributed to the absence of these buildings today.

We next hear of Kingston in 1087. William I's Domesday Survey tells that there were mills and a church here and it is the reference to the church that is intriguing as it implies a place of worship and, by so doing, provides provenance in location. It is highly improbable that, having erected an early church in one particular location, any subsequent church would have been constructed elsewhere. Reasoned conjecture therefore is that All Saints' Church stands close to, if not on, the site of local worship for over 900 years.

A church implies a community and people regularly travelling there to worship which, in turn, necessitates a means of accessing the site and if located on an island, as parts of Kingston were, the provision of bridges.

If frequent access was required it makes sense to build the structures with thought of permanence, and it is not surprising therefore that the earliest structures still remaining are the church, a chapel and bridge – all of which are made of stone.

We see construction and, subliminally, the children's tale of the three little pigs is reinforced in that we accept there will not be any straw or timber buildings still standing as permanence suggests solid masonry construction.

However, there *are* ancient timber buildings still standing in the town. Admittedly, they are not as old as the church, but they are there, though perhaps not where you first think, as one thing about Kingston is that all is not what it may appear to be. Modern buildings are made to look old, either with the addition of external timbers to suggest a Tudor past or with the addition of a date that we take at face value as being true, when it is not. I see these as youngsters trying but failing to be adults as it is soon apparent, when you look closer, that they have no real age at all. Conversely, there are older buildings in town that want to conceal their true age and have had a facelift to appear younger than they really are.

When you think of buildings in this way they tend to adopt human traits. There are proud, boasting buildings that make their presence known; there are quiet, humble buildings that stand to one side and watch; there are buildings that are old and happy to be so, and others that can be deceitful. As with people, they have stories to tell, although it is impossible for each to tell its whole story in the confines of this book. I believe that you will find they support and complement each other. As with any community there are young and old and each has a part to play.

The history of these buildings could not be told if people had not previously researched and written about them. While you may find things that you already know, there are

long-forgotten or overlooked features herein highlighted. I hope that you will make some new friends and become reacquainted with those that you haven't seen for a while but, as with true friends, you can pick up from when and where you last left them. I hope you will also see how buildings in Kingston have undeniably changed world history.

These buildings that you are about to meet have feelings; they want to talk to you; they want you to meet them; they want you to talk about them to your friends, and introduce them. They want you to care about them, and I hope that you will.

Market House.

The 50 Buildings

1. All Saints' Church (Mid-Twelfth Century)

This Grade I-listed church stands at the heart of Kingston upon Thames. There is no other building that can claim earlier positional provenance.

The earliest written record of the church indicates construction in the late twelfth century although, apart from concealed Norman footings at the base of the tower and a couple of fading Victorian photographs, there is little to suggest that this was once a Norman church. In the mid-fourteenth century the nave was rebuilt. There is inconsistency in the structure: the north columns are slimmer than the south columns and the easternmost pillar of the south side is greater than them all but has no base. It is as if different stonemasons were involved, which suggests a passage of time for the reconstruction. There is a subtle centring issue in that whereas the south side columns are centred on the south tower pillar, the north columns are off-centre and are to the outer edge of the tower pillar, resulting in the tower and the nave having different centres. The east end of the church dates from the fifteenth century; the waggon roof of the old chancel and the roof of both the chapel and old baptistery on either side also date from this period.

All Saints' Church from the south-west.

Recent refurbishment has gilded the wooden angels in the nave roof, which dates from the mid-nineteenth century. The rooves of the aisles are early eighteenth century.

In the mid-nineteenth century, interest in the ancient heritage of the town sparked a Saxon revival and to create a sense of antiquity, flint and chalk was added to the exterior. Raphael Brandon's 1862–66 renovation exposed a Norman doorway at the west entrance, but it was demolished and replaced by today's Victorian Gothic doorway. As tragic as this decision now seems, the remodelling did reveal evidence of the town's Saxon heritage. A fragment of a Saxon cross, now encased and displayed with honour, was uncovered in the fabric of the church wall, having long ago been used as insignificant building material.

The church is a great example of having to look up to see history. Outside, the tower is brick but walk back and you will see it changes to a stone base. In 1703 a great storm damaged the lead clad, wooden spire and top half of the stone tower. When rebuilt in 1708 it was decided not to rebuild the spire and local brick was used instead of stone for the reconstructed tower. The brick we see today is from a further renovation in the mid-1970s but the ancient tower is still hiding behind it, and the bell-ringers regularly climb the original hewn stone spiral staircase to the belfry.

Inside the church, look up at the northern face of the tower and you will notice internal windows that once provided daylight to the belfry before the roof of the north transept was raised.

The church walls are adorned with many plaques and memorials but there are two that, for me, bring history alive. The first is to 'IHON' (John) Heyton, Serieant of Her Majesty's larder, and to his wife. It is positioned midway along the south aisle and records John's service to the queens Mary and Elizabeth. This memorial intriguingly transports us back to a time when our alphabet had only twenty-four letters, there being no 'J' or 'U', so that IVNE is JUNE. See also the 'Y' with an 'E' above, which represents the Saxon letter 'Thorn' and is pronounced 'the', so 'Ye Olde Shoppe' is actually 'The old shop' and has never been 'Yee'.

Wall memorial to Ihon Heyton. Note the early sculpted form of 'Ye'.

Left: Memorial to Elizabeth Bate with cause of death.

Right: Carved graffiti in the Holy Trinity Chapel.

The second memorial is in the south-west corner. The inscription tells that George was the primary physician to Charles II, but the untold story is that Bate was also primary physician to Oliver Cromwell and, before him, to Charles I. He was appointed chief physician to Charles II, two months after the Restoration of the Monarchy and various sources tell of Bate hastening Cromwell's death. However, there is more. The fact that Elizabeth died on 17 April 1667 aged forty-six precedes '*Ex Hydero-Pulmon. Funesta Londini Conflageration Acceletaram*', which tells us that Elizabeth died from lung disease accelerated by the Great Fire of London. It is akin to a death certificate.

In the Civil War the church was used for stabling Parliamentary horses. Memorials were looted and ancient inlaid memorial brasses were removed and melted down. Perhaps it was at this time that someone whiled away an hour or two, carving the small skeleton on a chamfered corner of the wall of the Trinity Chapel.

2. The Old Bridge Foundations (Mid-Twelfth Century)

In 1828, Kingston's old timber bridge, the origin of which can be traced to the twelfth century, was replaced. Its timbers, which had regularly required replacement as the weather and the freezing of the river twisted and split the wood, were dismantled and auctioned. However, excavation in September 1986 for the new John Lewis store uncovered the bridge's stone foundations, which supported the ramp up from the road. These are considered to be of good-quality masonry construction, indicating that care and time was given in selection of material and building. Cobbles that lined the road surface were also exposed. The foundations are visible through riverside windows and can be visited on request and on Heritage Weekends.

Until 1729, Kingston had the first bridge upstream from London Bridge and if you couldn't cross there you would either use the slow ferries or come to Kingston.

Twelfth-century bridge foundations in the basement of John Lewis.

Aubrey, visiting Kingston in the late seventeenth century, wrote: 'This bridge hath twenty two Piers of Wood that support it, two great interstices for Barges to pass through; which twenty two Piers do contain 126 yards; besides at the East End thirty Yards wrought up of Stone and Brick; and at the West End twelve Yards; which contain in all 168 yards.'[1]

But why build the first bridge from London here? The simple answer is that Kingston was probably the most convenient location. The river here was once much wider and flowed between gravel islands, spits and bars. The church and adjacent Market Place stand on one such island and others are plainly visible upstream and downstream. One of them, Raven's Ait, is believed to be the site of the Treaty of Kingston in September 1217 which, when ratified at Lambeth, ensured that England would not become ruled by France.

A bridge provides speed and security in crossing and this implies, as Shaan Butters suggests in her definitive town history, that military strategy is often an instigator. As the foundations appear to date from the mid-twelfth century, the rebellions of 1135–54 or the 1170s could easily have prompted a quickly constructed timber bridge. However, increase in trade could also be a contributory factor and the nature of the stone foundations implies expenditure, consideration and time rather than military haste. The footings therefore suggest that the bridge may be more associated with the development of Kingston and its market around this time than a military campaign.

The bridge certainly played its part in the country's history. In 1452, Richard Duke of York marched south with his army and, finding closed gates at London, came here to cross.

On 13 May 1471, during the Wars of the Roses, Thomas Neville and an army of 20,000 Lancastrian supporters tried to enter London to release Henry VI from incarceration in the Tower and capture Edward IV's queen, Elizabeth Woodville, but was thwarted by the raising of the drawbridge on London Bridge. He too came to Kingston Bridge to cross but found that sections had been removed by townsfolk, which prevented the army crossing and reaching London. Edward IV returned to London and eight days later Henry VI was murdered, the direct result of the Neville's failure to cross Kingston Bridge and rescue him.

On 2 February 1554 Thomas Wyatt, who objected to the intended marriage of Queen Mary to Philip of Spain, marched on London, but finding the bridge was barred came to Kingston. He too found that the townsfolk had removed 30 feet of timber to delay his crossing and, as with Henry VI, the execution of a monarch in the Tower was the immediate outcome.[2] On 12 February 1554, just ten days after Wyatt's delayed crossing and subsequent arrest, Queen Jane, the rightful heir to Edward VI, was executed.

Lady Jane Grey should, I believe, be recognised as a true English monarch, just as twelve-year-old Edward V, one of the princes in the Tower, is now recognised as a king despite not having been crowned, his throne usurped by his uncle, Richard III. Edward VI declared sixteen-year-old Jane as his heir and, as Edward V before her, Jane wasn't crowned and Mary usurped the throne. There is no difference, but then history is written by the victors.

As you stand looking at the old stones laid out on the riverside and Old Bridge Street opposite, realise that were it not for the old bridge and the people of Kingston removing sections, Henry VI may have been released by Neville and Edward's queen held captive.

Stones from the Old Bridge and Old Bridge Street in Hampton Wick opposite.

Edward IV's defeat would have changed history. There would have been no Princes in the Tower, no Richard III, no Battle of Bosworth, no Henry VII and no Tudor dynasty. Also, had Wyatt not been delayed at the bridge, and had Queen Jane been released and restored to the throne, it is unlikely that Elizabeth would ever have become queen.

3. Clattern Bridge (Late Twelfth Century)

Clattern Bridge is Grade I listed and is a Scheduled Ancient Monument. As a working bridge, still crossed by traffic, it is the oldest such structure in London and is one of the oldest working road bridges in Britain. The earliest documented evidence for this bridge is a reference to 'Clateringebrugende' in 1293, describing the part of the town adjacent to and beyond the bridge.[3] The name is believed to be derived from the onomatopoeic Anglo-Saxon '*Clatrung*', this being a 'clattering' sound audible when wheels or hooves crossed the bridge. If so, then the name talks to us from 1293 telling us that, despite the Norman Conquest nearly 250 years earlier, the language of the common man had remained essentially Anglo-Saxon.

The bridge comprises three stone arches and is clearly visible from the footpath and steps on the River Thames side. It is built with stone, rubble and flint with stone bases,

Clattern Bridge from the Thames side.

two courses of facing ashlar and with flint and rubble above. In 1758 the south-east side was widened, suggesting either an increase in the volume of traffic to the town or an increased width of road traffic in the coaching era. The red-brick parapet with coping stone was added at this time as was a footpath, indicating early consideration being given to pedestrian safety in light of the increase in traffic. Any significance of the octagonal stone shaft in the centre of the bridge has been lost to time.

Aubrey, in 1673, writes: 'there is another bridge call'd Clathorn, built of brick that rises up high like a high nose.'[4] In 1813, the bridge is referred to by the shortened name of Clattern Bridge, a disyllabic name resembling Aubrey's Clathorn. Ayliffe tells that in 1839 the bridge had 'a very low parapet' and continues 'at this time the bridge had a steep rise and was barely wide enough for two vehicles to pass'. The fact that the bridge 'was a favourite lounging place for idlers who gathered there to discuss the events of the day and the news of the town' would not have helped traffic flow and, in 1852, the bridge was further widened on the upstream side and the parapet on the downstream side was raised.[5]

Today, Clattern bridge no longer 'rises up high like a high nose' as it appeared to Aubrey and later Ayliffe, which is indicative of the fact the ground level was once considerably lower and the bridge clearly a feature at the time.

Look out for the heron who keeps watch under the bridge and also the bank of submerged tubes on the right side of the left-hand arch. These are to assist eel migration. In the early nineteenth century Kingston was noted for its annual May Eel Fair, though this is unlikely to be reconvened as the European eel is an endangered species.

4. The Lovekyn Chapel (1309/1352)

This Grade II* building is considered to be the last freestanding private chantry chapel in England and dates back to 1352, although some care and renovation has had to take place in the last 650 years.[6] From the outside it presents as a rectangular building in English Gothic style, with three bays, gabled ends and two distinctive octagonal corner towers with crenelated turrets. Stone buttresses are provided to the south and west walls. The walls were originally finished with flint but, as part of the loving care and restoration in the late nineteenth century, the turrets, the east wall and part of the south wall were all faced with ashlar. The east and west walls contain similar Perpendicular windows, the south wall two and the north wall, visible by those attending Tiffin School or their car boot sales, has one.

The Lovekyn family is understood to have been an old Kingston family and Edward, born around 1239 and bailiff of Kingston in 1277, was a caterer and member of The Butchers' Co., one of Kingston's four early trading guilds. The origin of the chantry chapel in Kingston can be traced to Edward I's visit to the town in February 1299.[7] It is said that he was so well wined and dined that he invited Lovekyn to cater for the king's sumptuous wedding feast. Lovekyn duly obliged but did not get fully recompensed though, contrary to popular belief that Edward I reneged on the agreement, he actually authorised payments to Lovekyn.[8]

The failure to pay Lovekyn appears to have been an oversight in land ownership. Lovekyn's money was to be obtained from land that the king had already allocated to his queen as part of her dower.[9] Edward I died in 1307, leaving Lovekyn unable to draw money from the land. He had a dilemma and took his problem to Edward II who, in lieu of payment

Lovekyn Chapel from the south-west.

of his father's debt, on 11 June 1309, granted Lovekyn license to build a chapel and procure a chaplain to celebrate divine services daily for the souls of all departed.[10] By 1352 the chapel was in utter disrepair and needed to be rebuilt. Understandably the Black Death from June 1348 to December 1349 may well have played its part in the lack of repairs.

On 1 October 1352 Edward III granted John, Edward Lovekyn's son, a license to rebuild and it is this 'new' chapel we see today.[11]

After John Lovekyn died in 1368 there were no further Lovekyn bequests. Financial mismanagement led to sales of estate property. This was before Henry VIII's act of daylight robbery of the Dissolution, whereby free chapels and chantries were confiscated by the king in consideration of his great cost in the protection of the kingdom and to maintain his honour and dignity. The chapel was not part of the church and, being privately owned, should not have been confiscated as the king had no legal claim or rights to the property.

In April 1528, Isabell Rothwood bequeathed land and property such that a free school for Kingston should be purchased, and in 1557 Robert Hammond bequeathed money to the bailiffs of Kingston to set up a free grammar school there as well as in Hampton. These bequests, while not directly associated with the foundation of Kingston Grammar School, are considered as instigating an education mindset, leading to the town bailiffs eventually petitioning Elizabeth I for a free school.

In 1561 she obliged by presenting the property for the foundation of the 'Free grammar school of Queen Elizabeth' in Kingston.

By 1878, after years of neglect, the chapel was in a deplorable condition and had to be propped to prevent collapse. The consensus was to demolish it but, thankfully, the governors sought to retain it and, spurred on by renewed historical interest, and at a cost of £658, every part of the chapel that in 1886 could be preserved, was carefully dealt with and restored.

5. Wall by Lovekyn Chapel (Early Sixteenth Century)

Stretching away from the Lovekyn Chapel at a length of some 20 metres (75 feet) is a brick wall that most people ignore. It is, however, a wall of some significance and mystery and has a Grade II listing due to its courses of comparatively fine quality seventeenth- and eighteenth-century brickwork. What lies beneath these courses is the real quandary, as under the visible wall and buried below ground level are semicircular brick features thought to be from the sixteenth and possibly fifteenth centuries. As yet, no one truly knows what purpose these features served.

The accounts of the receivers at the Crown's appropriation of the chapel during the Dissolution provide a clue as there are other buildings listed: 'A 'le yarde on the north of

The Old Wall from the north-west.

the chapel, and the end of a shed with partition at the west end of the old shed there, and a stable situate at the west end of the shed.'[12] June Sampson tells of a purchase in 1738 'whereupon two barns lately stood'.[13]

The wall's semicircular foundations could therefore be part of the stable and shed, perhaps being supports for feeding troughs.

6. Coombe Conduit House, Coombe (c. 1540)

There are three Grade II* buildings located on Coombe Hill, which for 300 years or so were the source of fresh spring water to Hampton Court Palace. Each is a Scheduled Ancient Monument and the best preserved is the Coombe Conduit.

There is debate as to who commissioned the water system. The design of the sump chambers supports Wolsey whereas the construction of the conduit houses and later addition of the middle Ivy or Bush Conduit suggests Henry VIII. Either way, to supply the palace with spring water from Coombe is a feat of engineering. True, the Romans knew how to convey water and there are other schemes, but this supply served Henry VIII and his court and had to work!

Coombe Conduit – Lower Chamber House.

English Heritage puts the engineering into perspective, advising that the total pipework length was around 3.4 miles and the fall was approximately 129 feet, which created sufficient pressure to provide running water at the second floor of the palace.[14]

Despite expertise in jointing, leaks occurred and the distribution required a means to interrupt flow to facilitate repair. Sluice valves, the medieval forerunner of stop valves, were installed and to avoid tampering were protected within brick housings called tamkins. There were at least six of these but only one survives, Gallows Tamkin, on Coombe Wood Golf Course.

This system for conveying spring water was simple and ingenious. Buried brick feeder culverts channelled water from springs to a lead cistern, in the floor of the upper chamber, which acted as a settling tank allowing contaminants to drop to the bottom of the cistern. Water flowed from the upper cistern to a further cistern in the lower chamber after which filtered spring water flowed away. The pipes ran downhill across Fairfield to another Tamkin on the east bank of the Thames opposite Home Park and the palace.

In the early eighteenth century, knowing that fresh water ran nearby, people illegally tapped into the supply. Lindus Forge recounts: 'Ordered that Mr. ffort, Clerk of Hampton Court, examin the Conduit Heads, Receivers and Ducts at Comb, and open and clean such as are obstructed; and Cutt off all branches as are laid upon the Main, to private persons, having no lawfull grant of the same.'[15]

The water from the springs was last used at the palace around 1876 when pipes were damaged and later development in Kingston resulted in the majority of lead being removed.

In 1969, prior to the development of Coombe Hill Schools, a Tudor brick culvert was exposed, photographed and then reburied. So, beneath your feet in Coombe, spring water is still channelled through handmade Tudor bricks to the conduit houses but now runs either to waste pipes or back into the groundwater system.

The construction of the lower Coombe Conduit House is a mixture of patchwork stonework at the front and local red brick at the top and sides. It is almost certain that the cut stones were brought from somewhere else, the most likely source being from Merton Abbey.

So, did Wolsey start the scheme using his abbey engineers' experience and then, at the Dissolution, did Henry's engineers take over using stones from buildings at the abbey? Perhaps, after all the debate on the founder of the scheme, the supply might, one day, actually be attributed to both Wolsey and Henry.

7. Nos 5–9 Apple Market (c. 1540–1913)

This is a two-storey building, the top half of which is of Tudor timber and quite possibly the earliest timber construction in Kingston. Curiously, the lower half dates to 1913, which begs the question 'Whatever happened to the original Tudor ground floor?'

Prior to this parade comprising a bakery and café there was an old inn that extended from the corner of the narrow passage. Originally it was known as The Harrow but in 1861 it inexplicably acquired a sense of age and became The Old Harrow, the name it would retain for the next fifty years.

At the beginning of the last century the local Temperance Movement considered that Kingston had a surfeit of drinking establishments and successfully lobbied for a cull in

Above: Twentieth-century bakery and café beneath a sixteenth-century upper floor.

Below: Sixteenth-century roof timbers of the café.

which The Old Harrow was deemed 'redundant'. Its licence was revoked with the additional justification that its rooms were 'too low and dingy'.[16] Dingy was perhaps unfair as it could be equally applied to many retail establishments of the time, however Edwardian photos of the pub suggest that they had a point with its low headroom.

So what do you do if someone closes your premises, criticising the building in the process? 'Raise the roof' and complain or just set about raising the roof? They chose the latter and so, in 1913, the upper floor and roof was jacked up and a taller ground floor built beneath, the top then lowered onto its new base. When you use the bakery or café, the first floor above you is almost 400 years older than the floor you are on.

The Victorian diarist George Ayliffe tells that the old pub was a 'noted padding ken', a mid-nineteenth-century term for 'a lodging-house inhabited by thieves, footpads, professional beggars, vagrants'.

This could explain why the Old Harrow was targeted, but is Ayliffe's description fair and was the pub really a den of iniquity full of itinerants? The 1851 census reveals that lodging there was a pedlar, a wheelwright, three painters, a brick labourer, three railway labourers, a gardener, five tailor journeymen and a Chelsea pensioner. In 1861, when the pub had become 'Old', lodgers comprised: two labourers, another wheelwright, fourteen tailors and a dressmaker any of whom, perhaps, could have 'stitched you up'. After 1881, the pub ceased as a lodging house as census records indicate that only the publican and his family are resident.

Take the opportunity to dine upstairs in 'The Terrace Eatery' to see the ancient roof beams, which date from *c.* 1540. This is the time Henry VIII married his fourth and fifth wives but, in contrast to the fate of unfortunate Catherine Howard, when the Old Harrow had its head cut off, they had the foresight to fit it back on. As an aside, accounts suggest this later actually happened to Charles I, his head apparently being sewn back onto his body before he was buried.

8. Nos 37/41 High Street (*c.* 1550)

A Tudor dwelling with a distinctive 'jettied' appearance where, to increase floor space, the upper floors extend over the ground floor. This Grade II*-listed building is considered to be the oldest surviving domestic architecture in Kingston and is an example of an open-hall house being originally built without any chimneys.[17] The smoke from a central fire rose to the roof and was released through openings in the thatch or roofing and any smoke-blackened roof timbers visible today are nothing to do with the ovens of the pizza or spicy chicken restaurants now occupying the premises but are a vestige of times gone by. This is an oft-overlooked gem; few passing by or dining within realise or consider its historical importance to the town.

As well as having a market and being at an important crossing over the Thames, Kingston was a significant inland port and trading was at the centre of the town's development. Wealthy merchants built their homes and trading establishments in and close to the town, and this mid-sixteenth-century home of quite some quality is one such building.

Although it was later clearly converted into three separate premises where occupants traded from the ground floor and, most likely, lived 'above the shop', the original building has stood alongside the trading highways of the Thames and the Portsmouth Road for over 450 years.

A rare example of a Tudor Open-Hall House (No. 37 is on the left).

Ayliffe tells us that at one time this area of town was predominantly associated with the malting industry and maltsters occupied the long range of properties extending from the south to East Lane, which includes this dwelling. Later the property was occupied by one William Miles, a carrier, who in 1851 was the next-door neighbour of butcher Joseph Wilcox. Records show that for the next sixty years No. 37 was occupied by the Wilcox family and Joseph Wilcox, master butcher, provided meat to Claremont and proudly displayed the Arms of Queen Victoria over his shop window.

We tend to take the protection and preservation of buildings for granted but it only really became a conscious endeavour of the government after stark realisation of losses caused to our heritage by bombing in the Second World War. Until 1947 there was no government strategy, although various private movements had, as early as 1877, tried to protect certain buildings from decay and demolition.

How enlightened then was this Kingston High Street butcher when, in a 1891 Commercial Trade directory, Wilcox stated that

> The building is kept in remarkable repair, and presents some architectural features, typical of the age in which it was erected; but in the present day we think more of business than of sentiment, and although the house has evidently got into hands that can appreciate it as a relic of a bye-gone time and treat it accordingly, Messrs Wilcox and Son have also their trade to consider and have apportioned a part of the frontage to the uses of commerce.[18]

The phrase 'appreciate it as a relic of a bye-gone time and treat it accordingly' of 1891 is in stark contrast to the mindset of profit-driven developers and later planners of the 1950s and 1960s who, in that perfect world of hindsight, could have followed Joseph's lead. Perhaps the council should acknowledge the butcher's foresight and compromise and call their heritage policy the 'Wilcox Strategy'. The Wilcox family eventually diversified into the motorcar industry and well into the 1970s had premises opposite and further along the High Street.

After William Miles left, Nos 39 and 41 High Street were, for many years, owned by the Mould Family, who operated steam launches from Town End Pier from as early as 1891 until the business closed in 1976.

Imagine two brothers who wanted to build a steamboat but, living in their mother's small house in London Road, they had nowhere to build. As such, their first boat was built wherever they could find space and Sampson tells of their building it on the Fairfield. The boat was a success with eager Victorians and Edwardians wanting to hire their launch. They set about building a second boat and moved in alongside Wilcox butchers and converted the rear of their new High Street premises into a boatyard.[19] After the Mould brothers' retirement in 1976, the building was held for a time by Moss Brothers, Gentlemen's outfitters, before becoming the Pizza Restaurant. Continuing the association with meat, No. 37 is now operated by Nando's.

9. No. 14 Market Place (c. 1570)

Another Grade II-listed Tudor merchant's house, but this is situated in the town, which suggests that the trade was less associated with industry, such as malting, and was more of a commercial retail outlet serving the townsfolk and market. The building dates from around 1570 and, in its 450 years, has witnessed and contributed to the history of the town eventually finding national recognition in 1976 when a chance find led to experts from the Victoria & Albert Museum taking a keen interest in the tiny building.

The building is currently occupied by 'The White Company' but has previously been the home of Boots' photographic and earlier their record department (the days when Boots and Woolworths sold records) and prior to this it was once known as 'Ye Olde Segar Shoppe' run by the Nuthall's family. (Remember – Ye is 'The'.)

The earliest surviving record for the property is dated 1599, when Robert Norton let it to a draper named William Paltocke. It appears to have always been a shop with the merchants' dwelling above. After being a drapers' it became a grocer's shop and through the years, as history ran past at pace outside, the trade inside the shop saw diversification from groceries into wines, spirits and then tobacco.

A lease from 1762 refers to two rooms being lined with 'old paper' in contrast with the new blue-paper lining that was 'in the shop'.[20]

We don't think of wallpaper as having any historical significance, but it has not always been on walls and its presence demonstrates a desire to present a wealthier image than wattle and daub, timber-panelled or brick and plastered walls. Wallpaper in this shop made national news (at least in wallpaper circles) in 1976 when Boots were making alterations on the second floor, the old sleeping chambers. Behind wood panelling and pasted to a timber partition wall, Boots found old wallpaper with lace patterning and a *fleur-de-lis* watermark, which is now

Note the jettied floors and later columns and dentils. *Inset*: Sixteenth-century timbers inside.

considered to date to *c.* 1680. So, as Wren was starting the construction of St Paul's Cathedral, someone in Kingston with a pasting table and brush was modernising their bedrooms. The paper is of historical importance and was, at the time, the oldest wallpaper ever found in situ in Britain. It was carefully removed to the V&A Museum and can been seen online.

The building has revealed other secrets including, not surprisingly, an old cigar tin, but a seventeenth-century trading token from Cromwell's and George Bates' time and, during excavations for a lift pit, workmen found the buried remains of a chicken, a dog and sadly, those of a young child. There is, however, an as yet unanswered and intriguing mystery beneath the cellar that I hope modern technology will one day resolve. During her investigations in 1975, June Sampson met Boots' dispenser, Mr Arthur Grove, who had been at the shop for twenty-one years. He told of how, during previous structural reinforcement of the cellar, workman had uncovered a domed chamber beneath the floor. However, before Grove could arrange for an archaeological expert to inspect it, the workman had covered it over again. What was the function of the domed structure and when was it built?

10. No. 1 Thames Street (*c.* 1570)

Another Grade II-listed Tudor merchant's house and, in comparing this with the previous building on the opposite corner of Thames Street, one can easily be fooled into thinking that this is a much later construction. However, they are contemporaneous, the difference being the owner of this shop and house decided that whereas their neighbours may be wallpapering, they would upgrade the external appearance of their home to a Georgian town house while they continued to live in the timber-framed Tudor building behind the new facia.

The frontage presents the image of a Georgian town house with vertical symmetry and proportion while asymmetric Greek columns seemingly try to divide the façade to form a Golden Rectangle – all the rage in Georgian architecture. Coincidently, if you look back to The Old Cigar Shop on the corner opposite, where Ayliffe tells us that a Mr Denyer sold snuff and tobacco, you will see that an attempt has actually been made to change the age of the building with classical columns having been added to the façade as if to support the second floor. However, with the number of facelifts this building has had, it is not clear when these columns were actually added and, rather than previously 'modernising' the building, they could easily have been added in the nineteenth or early twentieth century to imply age.

If you have the opportunity, take a look inside and compare each building as both have the original structural timbers supporting the floors exposed to view and, whatever the outside façade may present, the Tudor heritage is clearly evident. The supporting timbers behind the slatted weatherboarding facing onto the passageway have been dated to before the Spanish Armada of 1588.[21]

Examination of the building and its associated outhouses in the early 1970s by the Kingston upon Thames Archaeological Society (KUTAS) revealed a detached kitchen block at the back of the building, the detached nature being a wise safety consideration. If your kitchen caught fire, it might not spread to the main building, although, as Elizabeth Bate witnessed, fires can easily spread.

Excavations revealed a tile-built oven dated as late as the fifteenth century, but the site is likely to have been occupied well before this as flint foundations of an earlier building (late thirteenth century) were also found at the rear.

The false Georgian façade hiding the carved Tudor timbers and King's Passage.
Inset: 'For the want of an apostrophe, history is lost!'

As with the building opposite, the ground floor was a shop and the upper floors the home of a wealthy merchant. We are told that behind the front cladding are unseen ornately carved outer beams emphasising the wealthy nature of the original owner.[22] Accounts tell of a previous survey of the basement finding blocked tunnels that initial investigation suggests run toward the Market Place and churchyard.[23] Pure speculation, but one has to wonder if these tunnels do exist whether one connects with the corner shop and the domed feature seen by Boots' dispenser Groves.

The adjacent alley down to the river dates back to medieval times and most likely has been there since plots around the market were originally set out. Kingston Market Place is believed to date from mid- to late twelfth century. King's Passage recalls the wealthy linen draper, land speculator, magistrate, bailiff and mayor John King who lived at Norbiton Lodge but operated his successful drapery store from the building. He is best known for purchasing 93 acres of Norbiton Common and then selling land to the National Freehold Land Society, which developed into New Malden, his land being the area today known as The Groves area of the town.

The pedant in me truly wishes that the passageway sign had an apostrophe to indicate that it is named after King but, sadly, people advised the council it was not required, and in that simple advice a small piece of history and association with John King was lost.

11. Nos 6/8/8a Church Street (Late Sixteenth Century)

A timber-framed Tudor tavern and later brewery that has been converted into three shops but which, despite modification and refurbishment, retains the appearance and structure of the original Tudor timber framing and so deserves its Grade II listing.

What's in a name? That which we call a Rose, by any other name would smell as sweet provided, that is, you like the sweet smell of malt and brewing.

Until 1867, when the building was converted to form the three shops we see today, it was a pub called at various times: The Rose (1523), The Nag's Head (1708), the Old Nag's Head (the prefix seemingly being added for effect, akin to the 'Old Harrow' as there was no 'new' Nag's Head), and The Albion (1840). In 1523 there is reference to The Rose ('le Roose') being owned by William Shale, who histories tell was one of Henry VIII's valets, though how he came to be the owner is not known.

It is timber-framed with a jettied upper floor, and stepping into the middle shop, courteously advising the sales assistant that you are 'just looking', you can still see the solid Tudor timbers that at one time would most likely have carried the weight of ale barrels. When outside, look at this building and the plots alongside and you may get a sense of order in the ancient building widths. Consider the three shops. These are divided equally across the width but this isn't simple sharing: the width is set by the span of timber between two vertical uprights and the spanning timber between vertical supports would be the height of the tree trunk before it divided into two boughs. So, the timber lengths and resulting spans from felled trees set widths and vertical supports. Medieval street frontages were often set by the perch (5.5 yards) and some ancient plots can still be identified today being close to multiples of perches.[24] After Church Street go back to the corner of Thames Street and starting with The White Company on the corner, see how the widths of today's shops can be seen as multiples of the same length. Some shops are double, others are triple, but there is definitely continuity of scale.

The sixteenth-century Rose Tavern with jettied upper floors. Note the width of the plots.

Behind the building, backing onto today's Union Street, was a Tudor brewery. In 1846 the brewery changed ownership from Flint & Shaw to Flint & East. It soon became simply East's Albion & Star Brewery. Joseph East was a Baptist and Kingston's first Nonconformist mayor. His election in 1865 followed the construction (1863–64) and consecration (1864) of the new Baptists' church in Brick Street behind his brewery – the street name was changed to Union Street after the Baptists' Union. In 1867, East, perhaps realising that the brewery's close proximity would seriously conflict with the church, relocated to Oil Mill Lane, which in time was renamed as Villiers Road. His premises there were later purchased by Charringtons and then VP Wines. Housing now stands on the brewery site and the association with brewing is recalled by Winery Road.

12. Nos 2–2a Church Street (Early Seventeenth Century)

Yet another Grade II-listed pub and one can perhaps understand the Temperance Movement (that dispensed with the Old Harrow) wanting a cull. Now a shop since the pub closed in 1984, it is actually another building that isn't quite what it appears. This is the Old Crown after which Crown Arcade and adjacent Crown Alley are named.

Another false façade, this time of brick.

The pub once had a rear yard with stabling and a well, and though the yard is now taken by premises in Union Street, the yard has been the scene of two unfortunate deaths recorded by the coroners, one apparently accidental and the other a clear case of foolish pride, but each separately confirming the proverb 'Pride goes before destruction, a haughty spirit before a fall.'

Coroners' inquests reveal that in June 1597, Christopher Atkinson, a master bricklayer, died of suffocation by water (drowning) in the well.[25] There was no established police force at the time, so after his death in the well it is unlikely that anyone looked into it. The second death took place on 26 December 1712. It was the result of bravado by soldier Angell Sparkes who boasted how great a swordsman he was and how well he could defend himself with just a broom handle.[26] Sadly, he was less adept than he thought and failing to parry a thrust was, in the parlance of the day, run through with his friend's sword, taking two days to die but absolving his friend of all blame.

This pub was once called The Chequers (1736), The Horse and Groom (1764), The Crown (1777), The Bull & Butcher (c. 1800) and The Old Crown (1830s to its comparatively recent closure in the 1984).[27] It stands facing the old Pig Market where, on market day, narrow pens of pigs would line the street and extend into the road – early road hogs, no doubt.

As with the Thames Street building it faces across the Market Place, the red-brick Georgian façade is a later addition, dating from around 1722, but the original timber-framed

The original early seventeenth-century building behind the eighteenth-century brick cladding.

building of the Stuart period can still be seen at the sides and from the rear. Although there is reference to a building on the spot in 1417 it appears that, by 1605, the original structure had decayed. It was rebuilt reusing timbers leading to the early seventeenth-century construction we see today apart from the eighteenth-century cladding in brick at the front.

In 1837 the Old Crown was kept by John Tickner who, fittingly, is described as having a rosy countenance to welcome his customers. Conversely, his son became a member of the Rechabites Friendly Society and a prominent total abstainer of the town.

The Old Crown was once the meeting place for another Friendly Society, that of the Noble and Ancient Order of Oddfellows. The pub closed in 1984 and was converted into a shop, above which there are two flats. The uppermost flat is understood to still have remains of the original seventeenth-century timber staircase.

13. No. 30 Old London Road (c. 1660)

This Grade II-listed, gable-fronted building with two segmental arched windows, is believed to be the earliest brick-built house in the town. The historical importance of this building to Kingston should not be underestimated or overlooked. It may be a charity bookshop today but it tells of an important local, field-based industry that served Kingston.

Believed to be the oldest brick building in town.

Oxfam have occupied this small and visually unremarkable historic building for over forty-five years, an eighth of the building's 350 years.[28]

At the beginning of the twentieth century, mayor and antiquarian Dr Finny had a puzzle that, try as he might, he could not solve. He had seen a trading token issued by a Robert Pearson in 1669 that depicted three rabbits. Finny knew of an alehouse on London Street called the Three Coneys and easily matched the token with the alehouse. Unfortunately there were no records to identify where the pub was located and Finny never found where the alehouse stood. His puzzle was solved fifty years later when an owner of No. 30 was sorting through old papers and, thinking they may be of historical interest, offered copies to the museum for reference. It became immediately apparent that this building had once been called The Three Coneys and, finally, the link with the seventeenth-century trading token was established.

Who issued the token and what of the building? Parish registers show that the Peirson family were local bricklayers, which, by inference, suggests that they were also brick makers.

The similarity between the brickwork of this building and that of Cleave's Almshouse opposite suggests that the family could easily have been involved in both and, in all

probability, built their own house then diversified into providing refreshment for the town and other brick makers working in the fields.

The local brick-making industry was extremely important to the growth of Kingston as the local area, especially Norbiton and Surbiton commons, possessed the raw material of clay, sand and timber for making bricks and timber brick clamps; one need only look at old maps to see the numerous references to brickfields.

It was possible to make bricks close to where they were going to be used, thus avoiding the additional effort and costs of transportation. For the expanding town and builders, bricks were considered cheap and readily available. For the brick maker however, the effort and expertise in making them was seldom reflected by the end value, ironically, because they were so local and available. If one could diversify into laying bricks or providing another service such as running an alehouse, as it appears this family did, then the better for all concerned.

Despite all the effort and the low cost of brick-making, construction in brick could be prosperous and the will of Anne Perison in 1695, widow of William, master builder living at the Three Coneys, lists, among other things, pewter tableware and pots and six leather chairs, all being a status symbol of successful tradesmen.[29]

The building ceased to be an alehouse before the mid-eighteenth century, becoming a private dwelling and then a florist until Oxfam's arrival in 1971.

Today, as a bookshop, it has many stories to sell, but its own personal story is just as interesting.

14. Cleaves Almshouse, Nos 49–71 Old London Road (1670)

The almshouse comprises a row of twelve terraced two-storey dwellings arranged as six dwellings, each side of a central hall and is Grade II* listed.

The building is of local brick construction and has an unusual appearance in that although there are twenty-four window openings at first-floor level, every alternate window being over a doorway, is bricked up, providing visible evidence of late seventeenth-century tax avoidance. The window tax of 1696 increased if a property's windows exceeded a set quantity, which varied through the duration of the tax until its abolition in 1851. Charitable buildings do not appear to have been exempt and so it was better to reduce the daylight in the bedrooms than to pass bequeathed money onward to the exchequer. The windows are all casement with lancet leading.

Over the central doorway is a plaque recalling Cleave's bequest and a fine sundial, both of which have recently been given a touch of loving care. The central entrance is surrounded by chamfered quoins set out against the red brick. Each dwelling entrance has a small shelter hood. There are twelve chimneys of which ten have two outlets but each of the end stacks have four outlets, suggesting internal differences at each end of the building.

Cleave's £500 bequest in 1668 (£58,000 today) was for six poor men and six poor women of the town 'of honest life and reputation' and 'single persons above sixty years of age'.[30] Biden, writing in 1852, provided a less politically correct opinion when he described occupants as 'either decayed tradesmen or their widows'.[31]

CLEAVE'S ALMSHOUSES.

Above: Extract from Biden (1852) indicating full complement of windows.

Below: The central hall and entrance. Note the tax-avoiding bricked windows.
Inset: Sundial and plaque with Cleave's family crest over.

The central communal hall ensured that the men's homes were decently separated from the women's. Residents (or inmates, as they were called) were provided with a silver plate engraved with Cleave's arms to wear on their sleeve on special occasions. They also received clothing and a coal allowance.

In 1880 the trustees of the almshouse had sufficient funds to enable them to erect four further houses for additional residents – two men and two women – and in 1889 married couples were able to benefit. In 1910, ten more houses were built at the back of the site, which created an internal garden area for the residents' use. In the 1990s the nineteenth-century houses were converted into single-storey accommodation and the original twelve almshouses were refurbished.

We tend to believe that if someone bequeaths money it will be spent, but in 1822 an investigation into endowed charities found that of the £200 left by Cleave in a codicil to his earlier will and received from his executors in 1669 and 1670 no part had been used or distributed. They decided that the money could be used to provide a pension of £5 per annum for two further poor women of the company. The investigation considered charity the noblest, highest and best attribute of human character and it continues.

In 2003, a legacy from Miss Blanche Audric of whom few, if any, of us will have heard of enabled a plot of land to be purchased and another terrace of six houses was built, completing the quad around the garden. It seems that the spirit of charitable donation and looking after townsfolk is still alive and well.

15. The Druid's Head, No. 3 Market Place (Late Seventeenth–Early Eighteenth Century)

Don't be confused by the name and two entrances; you want the building and entrance on the right beneath the Georgian brick façade and alongside the old alley to the garden where, in its heyday, there was the longest range of stabling for coach horses in the town. The building to the left is an imposter and has been the Swan, The Red Lion, the Hogshead and, when the party wall was knocked through to increase trade it too became the Druid's Head.

You may think you know the Druid's Head Inn but look again and appreciate the outside. When originally built, this façade would have been distinctive with its different-coloured bricks – Flemish-bonded red brick for the majority but with a top parapet of yellow stock brickwork, which would have stood out, as would the matching yellow bricks forming an arched lintel over each of the first-floor windows and the red brick on the second-floor lintels.

There are five windows at the first floor but only three at the second as two bays have been bricked. Are these by design or have they been closed up later? The different composition indicates a later infill as opposed to design, so window tax is a possibility.

This building is a Grade II*-listed treasure. If you visit no other building in Kingston then I urge you to take the time to visit this, the last remaining coaching inn of the town; a building that is still serving drinks and food, as it has done for around 300 years. I make no apology for stating openly that this is my favourite building in the town. Each time I enter or walk by I am transported back to the golden age of eighteenth-century coaching and people pouring into the inn after a potentially perilous ride from London across Putney Heath.

Above left: The Druid's Head. The alley led to the coaching horse stables.

Above right: The original staircase up to your room.

Below: A hidden eighteenth-century gem in the heart of Kingston.

Perhaps order a drink – it doesn't have to be ale – and out of respectful courtesy ask the bar staff if you can have a quick look at the old wooden stairs, through the first-floor light well window and through the door of the locked first-floor panelled private dining and meeting room. I don't believe you will be disappointed when you think of the travellers who, cold and wet, have wearily climbed the stairs before you or the characters from the past who have wined and dined in the dining room.

What stories the old wooden stairs could tell. The stairs in the Druid's Head are in their original location and when you look up to the plaster ceiling rose above, you are seeing what all have looked up at and seen over the last three centuries.

Jerome K. Jerome reputedly stayed at the inn before setting off on his riverside adventures and, in referring to the town, wrote: 'The hard red bricks have only grown more firmly set with time and their oak stairs do not creak or grunt when you try to go down them quietly.'[32]

As with The Old Crown, this inn has seen tragedy under its former name of the Lion & Lamb. It changed its name in 1832 when John 'Shiner' Walter, a member of the Ancient Order of Druids who used to have a Lodge temple amid a painted grove of trees in the Wheatsheaf pub (now Rymans), became landlord.[33]

In March 1735, John Baker, the landlord, was found dead and, ironically, the coroner's verdict was that he had died from excessive drinking (although it is not clear whether this was the result of a binge or years of sampling the goods). In September 1748, John Chalmers, a trooper in the Royal Regiment of Blues, quartered at the pub and was helped to mount his horse in the stabling at the rear of the pub. In moments he was thrown from his horse and broke his arm, leg and back, lingering for several days in the inn before dying. In March 1764, a maid found that her mistress, the landlady Mrs Piggot, had fallen down the stairs to the cellar and had broken her neck.

16. Picton House, No. 52 High Street (Early Eighteenth Century)

This is a comparatively modest house, built around 1729 and today named after Cesar Picton, who lived here for twelve years from 1795. His occupancy was relatively short compared with the history of the building, so why is it named after him in particular?

It has been awarded a Grade II* listing principally because of the remarkably lavish and complete 1740s internal plasterwork and panelling and because its past occupiers, not only Picton, reflect Kingston's role as both industrial centre and rural retreat. It was restored and converted to offices in 1981. The location of the house, which backs onto the river just upstream from the town and, more significantly, its wharf, meant this was a prized location able to support and serve the town's trading requirements.

The story of Cesar Picton is widely told but the focus always centres on his ethnicity whereas it is who brought him to England and why he was brought that are equally interesting aspects of the story. He is believed to have been around six years of age in 1761 when he was 'given' by a Captain John Parr to Sir John Philipps. Sir John's journal entry for 8 November 1761 advises: 'Went to Norbiton with Captain Parr and Lieutenant Rees, taking with me a Black Boy from Senegal given me by Captain Parr, also a paraquet [sic] and a foreign duck.'[34]

The nature of the gift does not suggest a chance purchase; it appears focused and intentional. A key, for me, as to why Cesar was brought to England, is the link between Sir John Philipps and Captain John Parr. Sir John became mayor of Haverfordwest in 1736.[35]

Parr's father, Thomas, was mayor of the town in 1730.[36] Thomas died in 1731 when his son John, who would later become a captain of militia, was only eight.[37] Sir John and Lady Philipps are known to have been keen supporters of local education. Is it too far-fetched to suggest that Sir John and Lady Elizabeth helped with John Parr's education and, quite possibly, his upbringing? In 1761, with Captain Parr in Senegal, two events occurred, either of which could have led to Cesar's subsequent arrival. Richard, the Philipps' only son, left home aged seventeen to enter Pembroke College and Sir John was elected MP for Pembrokeshire. Was Cesar therefore a present for Sir John and Lady Philipps, who he considered his 'parents', a congratulatory gift or a surrogate son for Lady Philipps to dote on after Richard left? Sir John died three years after Cesar's arrival and, aged nine, he appears to have been raised and educated by Lady Philipps and her daughters. When Lady Philipps died in 1788, Cesar used her bequest to rent this house and set up as a coal merchant.

Kingston's thirty-eight malthouses needed coke, which needed coal. Someone who could guarantee a supply of coal would make money, and Cesar, most likely dealing with Lord Milton, Sir John's son Richard, would have been able to guarantee coal from the Phillip's family's local mining contacts. He later purchased the building and lived here until 1807 when, looking to retire, Cesar sold and moved to a larger property in Thames Ditton.

Picton House from the south-east, with access on the left to the riverside wharf. *Inset*: Cesar's plaque.

After he left, the house was owned by a corn and coal merchant, leased to other professionals, and was used as a family home, an antique shop and a restaurant. In 1964 it was owned by Kingston Council and was earmarked by them for demolition. This led to a public enquiry wherein common sense prevailed and permission to demolish was fortunately refused. The building was converted to offices.[38]

The last word goes to Cesar and is a measure of the freedom of speech he had. When Sir Horace Walpole visited the ailing Lady Philipps in 1788, shortly before her death, he found the family amusing her by reading an account of the Pelew Islands (now Pilau). He wrote: 'Somebody happened to say that we were sending a ship thither; the black, who was in the room, exclaimed, 'Then there is an end of their happiness'. Walpole continued 'What a satire on Europe!'[39]

Only someone who felt relaxed, safe and socially secure in his standing and in the company of the Philipps sisters and presence of Sir Horace Walpole would feel able and be able to voice his opinion so openly, without fear of reproach. It is to the credit of Sir John and Lady Philipps that he could do so in an age when even trusted servants could not. No. I do not believe Cesar was ever a slave. He was cared for and, possibly, loved.

17. No. 17 High Street (Eighteenth Century)

There are some buildings where nothing of note has ever happened, but they aspire to be noticed. This Grade II yellow-brick building with its Doric porch and columns, circular-headed Venetian window and central pediment has quietly stood alongside and opposite buildings with more activity.

Quietly hiding in the High Street.

I want to help raise this building's self-esteem. I can hardly begin with the 1951 Grade II listing that finishes with the statement 'interior gutted' as that certainly would be far too demoralising; no, there must be something of note. I could mention that in the 1901 and 1911 censuses the house was the residence of William Horace Webb, a noted solicitor. In 1976, it was the London Steak House and today it is the Co-operative Bank.

So, what of the site? In 1979 excavations behind this building found a dump of discarded 'redware' pottery comprising jugs, pitchers, bowls, cooking pots, jars and dishes, some almost complete, dating to the late fifteenth and early sixteenth centuries.

Remnants of a large sixteenth-century oven were also found, suggesting that a malthouse may have previously occupied the site.[40] This would not be unexpected as there are numerous accounts telling of malting south of the Hogsmill. Kingston's most famous malthouse, a sixteenth-century building, was at Nos 25/27 High Street until 1965 when, despite it being 'protected' by a council preservation order, developers wilfully and illegally demolished the building and erected offices in its place.

This is an eighteenth-century reminder of an unknown but wealthy owner, sadly long forgotten.

If I mention that the first-floor window bays have ogee-shaped lead coverings you may look up 'ogee' and then remember to look at this fine building instead of rushing by. Saying 'Oh, gee, that's the building', while corny and making my ears burn, it may also make you smile as you see the lead shapes.

18. Elmfield, No. 115 London Road (1756)

People may glance toward this Grade II-listed Georgian House and be fooled into thinking there is nothing of interest because it is just a school. But take a moment to consider Walnut Tree House, as it was called until 1861, and you will see a grand house, yellow brick in Flemish-bond with considerable detail. You may initially see it as a brick cube but then, as you look, you'll see the off-centred full-height bay on south face with three tall sash windows per floor. You may then notice the brick band in header-bond that distinctly separates the ground floor from the upper floors. Above is a matching band over the second-floor windows but with a stone cornice that runs below the parapet at roof level.

Looking at the west façade, the one you cannot see from the bus, there are five window bays – the second and fourth bays are bricked on the upper floors. Considering the date of construction and that the window tax was by then well established, these are likely to be 'blind windows' by design rather than being infilled. The same appears to apply to the east wall.

It was built on the site of an earlier residence: the old farmhouse of Chapel Farm, adjacent to Lovekyn Chapel. Local clay tended to be rich in iron, creating the red brick we see at the almshouses and the wall alongside the chapel and Elmfield.

Yellow bricks, which had to be specially brought to the site from outside the areas, would have made a visual and social statement at the time. They boldly state that local red, iron-rich and comparatively cheap bricks are fine for the garden perimeter walls but not for the house. The bricks for the house have cost money, but its owner could clearly afford it. Large windows at ground and first-floor levels tell of the owners' intent on socialising, and the smaller square windows of the second floor subliminally tell you that the resident had a retinue of 'live-in' servants. This was a house that was befitting the owner's wealth

The original entrance was via the projecting bay with the door where the front window of the bay is now positioned.

and importance as well as being 'stately' enough to stand at the east of town, adjacent to Norbiton Hall and Norbiton Place.

The owner was Peregrine Fury, whose income of £200 (£24,000) between 1731 and 1749 was from Charleston, South Carolina – one of the original thirteen American colonies. Fury was the colonial agent (and hence the London voice) for South Carolina and was responsible for negotiating with royal officials and explaining the colony's needs to the Board of Trade.

In 1738, having purchased Chapel Farm, which was adjacent to the Lovekyn Chapel and originally, pre-Dissolution, was a source of its income, he let the converted farmhouse on short-term leases and spent most of his time in London. In 1756 he may have had thoughts of retirement and so demolished the farmhouse and built the grand house we see today, but, unfortunately, only enjoyed it for three years. On his death in 1759, his son and namesake inherited the property and married his neighbour, Ann Greenly of Norbiton Hall. Peregrine and Ann lived there until 1776 but he then leased the property for additional income. One of his tenants was Captain Richard Pierce, captain of the ill-fated East India Company's vessel the *Halsewell*, whose story of heroic self-sacrifice was recorded by the artist Turner and others. Unfortunately *Halsewell* didn't end well.

In 1851 the house was occupied by a merchant for the East India Company. A decade later it was a school for gentlewomen aged between nine and eighteen. Ten years later all thoughts of walnut trees had gone; trees, possibly planted by Fury's gardener, had grown,

leading to the house being called the Elms and occupied by a retired clergyman and his family. It had become Elmfield House by 1911.

In 1920 Kingston Council purchased the mansion and grounds and it served as a central clinic (medical, optical and dental) for the local schools and, in 1929, Surrey County Council purchased the site to form the basis of the new Tiffin Boys' School.

19. The Old Mill House, No. 79 Villiers Road (Late Eighteenth Century)

This Grade II-listed house is a private residence, so please respect its occupants' privacy. It is included for a similar reason to Picton House, in that it tells of an industry that supported and promoted the development of the town. Milling can be traced back to the Domesday Survey, where five mills are recorded for Kingston. Long before the Industrial Revolution, mills were at the forefront of mass production and enabled comparatively rapid production of flour, which would otherwise have to be ground by livestock or by hand. Milling increased production and, in turn, this supported and facilitated an increase in the local population.

It is not currently known who built the Old Mill House but perhaps, one day, papers will become available as they did for the Three Coneys and missing information will be provided. The house dates from around 1775 and is a two-storey dwelling with a basement, the light wells of which are now infilled but their window bays and lintels remain partly visible above ground level. There is a tiled roof hidden behind the brick parapet, which creates the linear Georgian frontage. The entrance has a decorative pediment supported by columns, beneath which is a semicircular fanlight. The pediment has dentils, which, as the name suggests, are detailed, small teeth-like blocks.

Left: The Old Mill House. (Please note and respect that this is still a private residence.)

Right: 'Mrs Volvolutum' appears to have evolved into 'The Helping Hand'.

Early in the eighteenth century the mill associated with the house was still grinding flour but it was then converted to produce linseed oil, possibly at the same time the Mill House was built.

Water power was not enough and technology and profit demanded a change, so a stomping steam engine was installed early in the nineteenth century, possibly by Thomas Boorman, who is said to have made his fortune here. For residents of the Mill House and Kingston, the thumping began. The steam-driven stompers operated for twenty-four hours each day and for six days each week, stopping at midnight on Saturday then starting up again at the stroke of midnight on Sunday. This thumping continued for sixty years, meaning that some people would have been born, lived and died, having experienced the pounding for 86 per cent of their lives. A further innovation, steam-driven hydraulic presses eventually replaced the thumping machines, and one has to wonder what the effect on the local residents was when the thumping finally stopped. However, every silver lining has a cloud: the pungent odour of linseed remained, drifting across the fields and into Kingston.

Coming out daily from the mill would be barrel-laden carts of linseed oil for use in paints, varnishes, ink, linoleum and a byproduct of the industry, 'cattle cake' – the flax stalks after the seeds had been stripped. It was used as fodder and ensured that nothing went to waste. Coal brought by barge to the wharves, whether by Picton or his coal merchant competitors, would be trundled on carts going in as the produce came out.

In the 1880s there was a proposal to connect Kingston and Surbiton stations and the oil mill was purchased by LSWR and closed. As we know, this link wasn't established and in 1895 the site was purchased from LSWR by James Smith and converted into a candle factory. This produced 40 tons of paraffin candles each week with wax imported from Burma. The site also produced soap, thus enabling Smith to clean up. The soap was known as Volvolutum Soap (called 'Volvo' for short).[41] On the packaging 'Mrs Volvolutum', who later morphed into a bizarre hand-headed creature called 'The Helping Hand', assured you that dirt could be removed from clothes without rubbing or soaking!

In 1892, Price's Candles of Battersea acquired the site and thereafter it became the Corporation Waste Site, accessible today via Chapel Mill Road. Just across Villiers Road to the west was Joseph East's relocated brewery, which was purchased by Charringtons in 1891 and later became Vine Products who, as VP Winery, produced British 'Sherry' until closure in the 1980s. Somehow this site has seemed to attract odours: oil, soap, candles and household waste with a hint of malt, beer and sherry, from across the road.

20. Nos 14/16 Church Street (1819)

If you approach Kingston Market Place from London this building has 'presence' and shouts 'Welcome to Kingston' perhaps even more than the Market House. Turning into Church Street from Clarence Street, or Norbiton Street as it once was, you cannot fail to notice this Grade II-listed building at the centre of the fork between Church Street and Union Street. As visual welcomes to the town go, this building was a distinct improvement on Mr Lewis' slaughterhouse that had previously greeted travellers from London. This prominent landmark building symbolises a long-forgotten and significant milestone in the town's social and economic history.

The Kingston Savings Bank and later attic.

So why is this particular building important, other than being at entrance to the Market Place? The first bank in Kingston, formed in the last decade of the eighteenth century, was Rowlls and Co., a private arrangement with Mr William Rowlls, a wealthy draper who was related to the wealthy brewing family. Rowlls and Co. later became the Shrubsole and Co., then Parr's Bank, then the Westminster Bank and following later mergers, the National Westminster bank.[42] However, the original bank did not help the poorer people of the town as one had to have £10 (£770) to open an account.

In November 1817, a group of local philanthropists formed the 'Association for bettering the condition and morals of the poor in the town and neighbourhood of Kingston-upon-Thames'. The Association focused on 'the pecuniary circumstances of the poor. To meliorate these, it was considered necessary to encourage a habit of providing, where practicable, against the approach of sickness or infirmity, by furnishing them with the means of investing small savings, in such a manner as to produce accumulation of Interest; It was accordingly proposed to establish a Savings' Bank in the town of Kingston. Immediate measures were taken for that purpose'.[43]

In the first annual report (1818) the treasurer advised: 'the Bank has been open one hour every week, and the average weekly deposit has been about £50 (£2,903). The sums deposited have been generally small, and the depositors consist principally of Friendly

Societies, Mechanics, Servants, Labourers, and those classes of persons whose prudence and economy the Institution was principally intended to promote'.[44]

Kingston appears to have been at the forefront of social change in this respect as the *New Monthly Magazine* advised in February 1819 that, 'At no place in the whole kingdom are the good effects of bettering the morals and condition of the poor, more visible than at Kingston-upon-Thames ... which, from its being it town of considerable trade, abounds with a very large proportion of the labouring classes.'[45]

Merryweather wrote that: 'It is now almost as easy for the poor to become rich, as it is for the ignorant to become well informed. The Savings Bank and Penny Banks receive on Government security the smallest scrapings of the labouring man.'[46]

The new Kingston Savings Bank initially operated from the old Town Hall (now Market House) but this was in a poor state of repair and there was talk of a new town hall being required and the new savings scheme naturally looked for a new home. This was provided by William Mercer, wealthy owner of the mill closest to the town (previously Hogg's mill), who purchased Mr Lewis' slaughterhouse at the corner of Brick Street (later Union Street) and Church Street. Mercer went on to become a town bailiff in 1833 and then mayor in 1839.

In 1819 the Kingston Savings Bank building, funded by William Mercer, provided a new home and the bank ran, with the help of volunteers, for fifty years. Eventually better bank deals and the new Post Office Savings Scheme, which began in 1861, saw accounts in the KSB being closed and money transferred.

For a while the front of the building was occupied by the Kingston Gas Co. and upper offices used by the town clerk and solicitors Wilkinson, Howlett & Wilkinson, which closed on the retirement of Arthur Howlett in 1927. The building subsequently became Luxford's fruiterers and later Millets, Jean Machine and Monsoon. At the time of writing it is home to Accessorize.

21. No. 30 High Street (Early Nineteenth Century)

This building has no listing and is considered, for all intents and purposes, to be of no particular architectural merit or historical significance. Fortunately, Kingston Council considers it a building of townscape merit. The plaque on the wall tells you that this was the childhood home of Edward Muggeridge (he later changed it to Eadweard Muybridge), but the story of his life is far too detailed to condense herein. It has been told on paper, in bytes and finally most fittingly, in the 2015 independent film biopic *Eadweard*. If by chance you do not know of Muybridge, then I recommend you visit the museum where his story and original media-changing invention await you.

The plaque states that he was a 'Photographic Pioneer' but this is a gross understatement. If you have ever heard of the question as to whether a galloping horse lifts all its hooves from the ground, it was Muybridge whose photographic arrangement proved that it does. He successfully converted live animal movement into still photographic frames but it was his reversing of the process and the turning of still photographs into movement for which he is remembered. He subsequently bequeathed the apparatus he used to Kingston Museum, where it remains as a cherished and honoured collection and exhibit. If Edison with his Kinetograph are considered as the father of the movie image and industry, then Muybridge was the grandfather or, at the very least, a respected great-uncle.

The birthplace of the 'Grandfather of the Moving Picture'. *Inset*: It is believed that Muybridge used the spelling for Edward he saw on the Coronation Stone plinth.

22. The 'New' Bridge (1828, 1914, 2001)

By the end of the eighteenth century it was clear that despite 600 years of running repairs, this narrow bridge would not withstand further damage from wind, ice or the incessant pounding of trade vehicles. The problem for the town was that there was no money.

In 1821, the Bridge Estate's annual income was only £163 9s 4d (£9,500), whereas in the nine years between 1812 and 1821, expenditure was £2,460 (£143,000).[47] A balance sheet for this period would indicate that, in today's money, outgoings exceeded income by £57,500. Land belonging to the estate was mortgaged to meet the cost of repairs but this was not sustainable as it reduced the future income.

In 1825 Kingston applied to Parliament and an Act was passed enabling the corporation to levy tolls, which would be used to repay the initial outlay for a new bridge. A competition for the design was held but, with increasing cost of metal, designs for a cast-iron bridge were rejected, a decision that would serve Kingston well years later. The winning design, for a stone bridge, came from Edward Lapidge, County Surveyor of Surrey.

Lapidge's 382-feet-wide bridge has five arches spanning the river, the centre being 60 feet wide and 24 feet high with arches decreasing in width of 56 feet and 52 feet respectively.[48]

Above: Kingston Bridge from the upstream Surrey side. *Inset*: An 1828/9 sketch of both the new and the original wooden bridge. By 1829 the old bridge timbers had been auctioned and sold and the bridge demolished. Note the gap on the right of the old bridge, which is from decay but resembles what two rebellious armies may have faced when coming to the bridge. Note also the tollbooth on the right of the new bridge.

Below: Two flood arches were provided on each side. These are on the Middlesex downstream side. Note the absence of Portland Stone cladding. A tollbooth occupied the top of the round projection from the bridge.

The bridge actually has a total of nine arches. Lapidge lived in Grove House Hampton Wick and was acutely aware of the tendency of the river to flood and cause damage. His design therefore allowed for two flood arches at each side. Look west across the river and you will see two, apparently superfluous, arches on the far side, which span an old waterway that floods when tides are high. The bridge lands on a raised gravel island clearly evident on old maps, and the two additional arches are where the Thames originally continued around the island. There were a further two arches on the Kingston side but today there is just the one we walk under.

The cost of the project was £40,000 (£2.75 million), which included modifications to the approach from Kingston, where houses were demolished to create a direct approach from London Road, being a Market Place 'bypass'. Kingston unsuccessfully tried to get Surrey and Middlesex to pay for the construction; tolls had to be introduced and were set at: passing on foot – ½d (15p); wheelbarrow or cart – ½d; one horse pulling a cart, chaise or carriage – 3d; each additional horse – 1½ d; and so on with every sheep, cow or pig – 5d (£1.50).[49]

Despite a minor setback when one of the 'dry' arches partially collapsed, the new bridge was formally opened on 17 July 1828 by the Duchess of Clarence (hence Clarence Street) who later became Queen Adelaide.

The annual income from tolls averaged £2,000, so even without the 3.5 per cent annual interest the repayment would take at least twenty years. But there was interest, and by 1870 there was a considerable sum still owed. Tolls were also levied on bridges upstream and there was a general feeling of dissatisfaction, which led to lobbying of Parliament. An Act was passed increasing revenue on coal and wine releasing the corporation from its debt as well as similar debts upstream. On 12 March 1870 the bridge was declared 'toll free for ever' by the Lord Mayor with a great display of fireworks.

In 1906 trams were introduced, and as the bridge was only 25 feet wide, it was clear that with the two tram tracks leading to and from the Hampton Wick terminus, where the roundabout is today, there would be congestion.

Delays in crossing were alleviated by the widening of the stone bridge in 1914, which would not have been possible had a cast-iron bridge been built in 1825. In 1998, it was considered that to meet traffic flow predictions two lanes of traffic in both directions and a central bus lane were necessary and the bridge was widened a second time on the upstream side, which and was finally completed in 2001.

Looking at the bridge you will see the three stages of it, with the centre red brickwork of the 1914 widening sandwiched between the original 1828 on the downstream side and the 2001 brickwork on the upstream side. The bridge was awarded a Grade II listing in 1951.

23. Market House (1838–40)

For me, the Grade II*-listed Market House represents Kingston upon Thames. No other building comes close. It exudes style, presence, and heritage; all surrounding buildings look inward to it as if in reverence or respect; people are drawn to it and are protective of it. It presents a powerful and unforgettable image but is not overbearing and is forgiving of the lesser subjects that surround it. It is therefore truly majestic and this word is carefully chosen. It is the king of Kingston's buildings and, as is befitting a king, it has a radiant golden queen who, somewhat surprisingly, people mistake for Queen Elizabeth or Queen Victoria when it is actually Queen Anne.

Above: The Market House from the south.

Below Left: The bell tower. When and why does it toll?

Below Right: Queen Anne statue by Francis Bird. He also sculpted the original stone statue of Queen Anne outside St Paul's Cathedral in 1712 but this was severely eroded by 1885 and was replaced by a Richard Belt replica. The Bird original is now in the gardens of Holmhurst, in Baldslow, Sussex.

I personally feel that the Market House also stands as a symbol of the voice of the people of Kingston and were it not for them we might never have had this central jewel.

By the end of the eighteenth century the old Town Hall was in a sorry state and too small to meet the increasing administrative requirements of the town, the needs of the Guilds and Court of Assembly and the separate needs of the Lent Assizes and Sessions courts. By 1837 all agreed that the old building needed to be pulled down. The borough council decided that the New Town Hall would be relocated out of the Market Place and built alongside the Assize Courts overlooking Clattern Bridge.

It was then that the voice of the people of Kingston was heard. Many people considered that the Town Hall was an integral part of the Market Place and that the council's proposal to relocate away from the market was not what the people wanted. In a decision that resonates down to today, the council acknowledged and accepted the people of Kingston's view and the power of public opinion successfully changed the council's decision.

The replacement Town Hall would now be built in the centre of the Market Place, but what would it look like?

An architectural competition was held and twenty-three schemes were submitted. The contract was finally awarded to twenty-four-year-old Charles Henman who, in January 1838, had just been elected as an Associate of the Royal Institution. His design, in the Italianate style, echoed the resurgence of the form originally introduced by Nash in 1802.

Little is known about Henman. He studied under Middlesex County Surveyor William Mosely and was well versed with institutional buildings. He married Louisa Whitfield in Clapham in April 1844 and four years later he is known to have answered an advert placed in *The Times* and *The Builder* for an architectural design for the proposed new workhouse at South Stoneham (now Eastleigh), Hampshire. The committee chose Henman's designs but he declined to accept a monitering role on site and so received just £50.[50]

He had two children, Charles and William; each later eclipsed their father and became highly respected architects, with Charles Jr designing Croydon Town Hall and William specialising in hospital design and ward ventilation.

Henman appears to have been financially assured as, at his death in 1884, the RIBA President Ewan Christian wrote: 'an able man, who, if he had not been possessed of independent means, would probably have made his mark more strongly than he did.' I believe the people of Kingston consider that he made a strong enough mark for the town with this fine building.

Local mason, John Trigg, tendered £3,832 (£234,078) for the contract. The ground-floor cast-iron beams and columns were supplied by T. Francis, a Kingston foundry south of Clattern Bridge whose cast-iron railings are still seen on Queen's Promenade and on the Hampton Wick side of the bridge.

Henman's design retained the ground-floor market and was originally open-sided, the reason that the floor is constructed in stone slabs. The open arches were infilled with windows toward the end of the nineteenth century. The south room on the first floor, which is a lovely tearoom today, was known as the Justices' Room and council committees and magistrates met here in petty sessions. The small room, today used as the kitchenette for the tearoom, was built as a supposedly fireproof room suitable to protect the town's archives and regalia and to protect the bell in the south-west turret.

The larger room was the council chamber. The building ceased being called Town Hall and became Market House in 1935 after construction of the new Guildhall just where the 1837 council had originally planned.

There are a couple of unanswered questions regarding the bell, these being the whereabouts and purpose of the original one. Accounts say the original bell from the old town hall was transferred with the queen's statue whereas English Heritage state that there is a new bell cast in the Whitechapel Foundry by Thomas Mears in 1840. If the latter is the case, what happened to the earlier bell? As for its purpose, when is the bell tolled and would you know what it meant if you heard it? Sorry, for me it remains a mystery. The only bells I've heard ringing come from the church and even the 'Pancake' Bell, which started and stopped the annual Shrove Tuesday football match in the Market Place, was the tolling of a church bell.

If you haven't been inside the Market House, I've told you there's a tearoom – you know what to do. Long live our King of Kingston!

24. Church of St Raphael (1847–48)

You most probably thought that the principle of 'buy one and get one free' was a relatively recent concept, but getting two for the price of one appears to have been very much what wealthy Surbiton resident and later St Albans MP, Alexander Raphael, had in mind when he approached architect Charles Parker for a design for his new church in the mid-1840s. Not many people know that this Grade II* Roman Catholic church has an identical twin, 50 miles away in St Albans.

Raphael was born in Madras in 1775, the son of a wealthy Catholic merchant. In 1791, following his mother's death, he came to England with his father and siblings but his father died en route. Alexander (sixteen) was left to look after the family. However, a rich Armenian arriving in England at the end of the eighteenth century was different to a poor Armenian. He was fortunate to be the former through inheritance. Little more is heard until later life when, aged seventy, he became seriously ill and vowed that, if he recovered, he would build a church. Despite, or perhaps because of, treatment by Kingston physician Dr Roots he recovered, but believing in divine intervention he refused to pay Roots and, keeping his vow, he employed one of the original fellows of the Institute of British Architects, Charles Parker, to design his church.[51]

Parker had travelled extensively throughout Italy and in 1832 published a series of plates that formed his 'Villa Rustica', which was highly influential in the Italianate style and which, most likely, influenced the young Charles Henman with his Town Hall design.

The church was built for Alexander and his family's private use on his new estate, Surbiton Park, and was completed in 1848. It only became available for public worship after Alexander's death as part of his bequest to the Roman Catholic faithful of Kingston.

Completion of the church coincided with revolution in France. Queen Victoria offered the exiled French royal family a home at Claremont and they worshipped at the church. In 1881, the Empress Eugenie, widow of exiled Emperor Napoleon III living temporarily in nearby Coombe, worshiped at the church.

Midway along the left wall of the church interior is a memorial to Raphael's great-niece, sixty-three-year-old Princess Anne of Lowenstein Wertheim Freudenberg, or simply Lady Anne Saville. Hearing that two RAF pilots were attempting to cross the Atlantic, she decided to accompany them and become the first woman to fly across the ocean. Dressed in purple-leather knee breeches, a matching jacket, black-silk stockings and high-heeled fur-lined boots, she told reporters, 'I am proud to be the first woman to attempt the crossing.' She strapped

Above: Church of St Raphael, Kingston. *Inset*: Memorial to Princess Anne of Lowenstein Wertheim Freudenberg.

Below: Christ Church, St Albans, now deconsecrated.

herself into a wicker chair placed at the back of the cockpit of the 'St Raphael', stowing her only luggage, two hat boxes, under the chair. On 31 August 1927 at 7.30 a.m. they took off. At 9.44 p.m. a tanker sighted the aircraft 800 miles west of Galway. The 'St Raphael' had been flying for fifteen hours due west towards Newfoundland and was seen approaching a thick fog bank. A year later, one of the plane's wheels washed up in Iceland.

In 1847, Alexander Raphael (aged seventy-two) became MP for St Albans and three years later, having just seen the completion of his private church, he decided to build an identical church as a new Roman Catholic church for the people of his constituency in St Albans.

He died during the construction and the unfinished church was sold by executors to Isabella Worley, who saw to the completion of the church in 1856. However, Mrs Worley was Anglican and the church, when consecrated, became Christ Church – it is now an office building.[52]

So we have one client, one architect, one design, two churches and two separate faiths and the founder of both churches never lived to worship in them. Mysterious ways indeed!

25. Royal Cambridge Asylum Lodge, No. 41 Cambridge Road (1854)

Once again, this is a private house so please respect the occupants' privacy. This small house is a surprisingly unlisted early Victorian lodge or gatehouse and is all that remains of the only institution in the country in its day that provided a safe home for soldiers' widows. The term 'asylum' was used in the sense of 'a place of security and protection to be sought' as opposed to its more stigmatic medical connotation.

The exterior is full of architectural detail, including Dutch Gabling; brick dentils; four course white-brick banding that separates the red brickwork of the ground and first floor while, at the same time, aligns with the ground-floor flat-arched lintels; a two course white band that aligns with the cills; alternating red and white arrangement of the soldier lintels; a front bay and parapet that forms a balcony at first floor; white-brick window surrounds; an arched front doorway; and a carved monogram of RCA over the entrance and decorative chimneys. Visually, it is a lovely building and so pleasing to the eye that as you stand looking at it you will keep seeing different details. I cannot say whether the gate is original but that too is a small work of art.

The asylum the lodge house served was founded in 1851 by the 2nd Duke of Cambridge in memory of his father, the 1st Duke (seventh son of George III), and was for widows, aged fifty or over, of privates and non-commissioned officers. The aim was to make them 'Happy, comfortable and free from the cares of poverty'. There were 160 residents and each had a furnished bed-sitting room with a small scullery enabling them to prepare their own food. They had electric light, a monthly allowance of 2s 6d (£8.37) for coal and received a weekly income of 7s (£23.50).[53]

The 'inmates', as they were referred to (although once again this does tend to skew one's image when used in connection with an asylum), were admitted by election with the governors and subscribers voting by ballot. The selection did not give any priority to women whose husbands were casualties of war – they solely had to be widows.

Funding and support for the asylum generally came from donation but following the success of a contest between regular soldiers and militia held in Islington in 1880, two years later the event was so popular that it could make a significant financial contribution to the running of the asylum. In 1906, the contest moved to Olympia and became the Royal Tournament. Hearing of this new funding, the aged Duke is reputed to have said that

The Asylum Lodge. (Please note and respect that this is still a private residence.) *Inset*: The insignia RCA (Royal Cambridge Asylum).

there is 'hope that every Regiment in the Army will soon have a widow in the Asylum'.[54] I suppose he meant well.

In 1944, a V-1 bomb seriously damaged the building and the residents moved to East Molesey, where the Royal Cambridge Home provides a similar service today. After the war the building was demolished and flats built in its place, but the little Lodge on the corner remains to catch our eye when we have a moment.

26. No. 1 Market Place (Mid-Nineteenth Century)

The Grade II-listed former Griffin Hotel occupies a commanding position, at the point where Market Place becomes High Street. It is best viewed from Eden Street. Its dominance on the corner, with its two separately angled façades, clearly suggests it was at one time two separate buildings that were subsequently joined. The earliest record of the Griffin is 1552, but the current façade dates from the mid-nineteenth century when it was refronted by John Williams, who became its proprietor in 1852. Williams later became mayor three times and is one of those many mayors to whom the people of Kingston today owe so much and yet, like the others, he is not given a first thought, let alone a second thought or a memorial.

The exterior of the Griffin, once known as the Golden Griffin (hence the sign under the pediment), is instantly recognisable as a former coaching inn but it is easy to be fooled by the comparatively modern refurbishment. The carriage entrance was not through the walkway we use today but originally was to the right of the current entrance and would have taken you into where the patisserie stands today.

As with so many buildings in Kingston there is a pearl of history hidden within the shell if only you choose to look for it. At the first floor rear of the building, hiding behind the yellow-brick wall and eight windows with red-brick arches, is an 1860 assembly room and ballroom

Clearly this was two separate buildings in the past. *Inset*: A royal coat of arms not known to have been formally awarded.

that currently forms the upper-floor dining area for the restaurant on the rear corner. You cannot simply walk up there so, if you can choose a time when they are not busy and ask if you can see the room or alternatively wait until you see that the ground floor is packed and then go there for a drink or a meal and ask to be shown upstairs. Prior to Williams' arrival in 1852 the hotel was run for twenty years (1828–48) by Robert Moon. In a letter to *The Sporting Magazine* of May 1830, Moon is described as being 'remarkable for his great attention to his customers, more especially those who rattle up to his door in a carriage: when this happens, let Moon be seated where he will, nothing can prevent his immediately going out to welcome the arrived guests.'[55] By all accounts it appears that even if Moon was in conversation with a new guest or people he knew, he would 'quit his fellow townsmen and go to welcome the strangers'.[56]

It became a standing joke in the town and, it seems, further afield as the letter prompted a response the following month. J. Bissett of Leamington Spa wrote a five-verse song, two verses of which describe Moon's eagerness to welcome guests:

> The moment a coach or a chaise, be they drawn by two horses or four,
> Approaches the inn call'd 'The Griffin', a Moon will appear at the door.
> Tis delightful its motion to see, its quickness is truly surprising,
> Tho' gentle the Moon of itself, coach-wheels give a spur to its rising.
>
> All have heard of 'the Man in the Moon, with his bundle of wither-ed sticks',
> But you probably ne'er heard before, of the Kingston Inn Moon (or his tricks),
> Should you wish to behold him, you may, you'll oft find him cheerfully whiffin'
> His pipe-or else 'wetting his clay', if you'll call on the Moon at The Griffin.[57]

However, in 1848 with the inn's trade failing, perhaps as a result of the decline in the coaching traffic, Moon left.

Another hidden gem, this old Assembly Room-cum-Victorian Ballroom, at first floor over the restaurant.

Williams succeeded in changing the appearance and fortunes of the inn. He renovated the Charles II frontage and built the assembly room, where he held balls attended by nobility and, it is said, royalty. He incorporated the Post House and he styled himself as a 'Royal Postmaster' and mounted the royal coat of arms that is still displayed over the doorway.

As mayor, he oversaw the construction of the Queen's Promenade toward Surbiton but should, I believe, be remembered and credited for his foresight, perseverance and philanthropy. In 1859 he saw the open areas of the Fairfield being diminished and sought subscriptions to buy the land to save it for the town. He was met with apathy, spite and hostility. He managed to enclose 12 acres using, for the most part, his own money but received no thanks or even acknowledgement for having done so. He died in 1872, seventeen years before the Fairfield Recreation Ground opened. Without Williams' purchase there would be little or no open public recreation area at the Fairfield. When next at the Fairfield take a look at the Victorian cast-iron railings enclosing William's '12 acres', as these are most likely from T. Francis' Foundry again.

27. Seething Wells Waterworks, Portsmouth Road (1851–52 and *c.* 1858)

Kingston has long benefited from freshwater springs but in South London, before 1852, water was taken from the Thames. William Heath's 1828 work 'Monster Soup commonly called Thames Water' gives an insight to what people knew, yet they still

Right: A 'simple' Victorian Coal Store.

Below: 'Monster Soup commonly called Thames Water' by William Heath. This was painted twenty years before Lambeth Waterworks Co. relocated. If people knew or even suspected this why would anyone drink the water? Thank goodness for people like Ron Ruggins.

drank the 'soup'. (In a strange coincidence, having written that line my doorbell rang and Thames Water Officer Ronald Ruggins asked if he could sample the quality of water from the Kitchen tap. While sampling we discussed the history of piped water supplies. Thanks Ron and TWU.)

In 1852 Parliament passed the Metropolis Water Act to 'make provision for securing the supply to the Metropolis of pure and wholesome water'. It became unlawful for any water company to extract water for domestic use from tidal reaches of the Thames after 31 August 1855, and from 31 December 1855 water had to be 'effectually filtered'. Lambeth Water Co. was ahead of the Act, having decided in 1847 to move their intake to Seething Wells. The tidal reaches started at Teddington Lock and Seething Wells was as close as practicable to London while still complying with the Act. There was ready access to London running alongside the railway. Chelsea Waterworks Co. relocated to Seething Wells in 1856 and was the last water supply company to draw water from the tidal stretch of the Thames. The area they vacated subsequently became Victoria Train Station.

There are a number of Grade II-listed buildings on this site and it is worth taking a tour when you visit as there is a lot to see. In essence, to clean the fresh water from the Thames it needed to be filtered and large sand-filter beds were constructed. The filtered water then had to be drawn from the filters and pumped to London. The pumps were large steam-driven engines – steam requires heat – and we are back to Kingston being an inland port with barges of coal being brought from London and beyond. The demand meant that coal needed to be stored and the feature of this site, aside from the old pump house and offices, is the architectural design given to two open coal stores.

Lambeth Water Co.'s coal store and tower was designed by civil engineer James Simpson, who had introduced sand filtration at Chelsea. Built in the Romanesque style with rounded arches, the store was capable of holding 1,500 tons of coal. To differentiate between the adjacent companies, Simpson designed Chelsea Water Co.'s coal store and tower in the Italianate style.

Tunnels with tracks run from the base of the towers under the Portsmouth Road to the riverside coal wharves where barges of coal unloaded into trucks that were pulled back under the road on the tracks by steam-driven engines. Simpson also designed the Chelsea Office/ Lodge with its Italianate tower. The main pump house, which at one time pumped 40 million gallons of water a day to London, has now been converted into recreation and health centres.

Seething Wells played a key role in the discovery of cholera. John Stow used Lambeth's sand-filtered water to compare its quality and content with water from town pumps and wells. The site was a grand venture but, after twenty years, the sand-filter beds became silted and in 1872 Lambeth Water Co. moved upstream to Molesey; ChelseaWater Co. followed in 1875.

28. The Old Police Station, No. 22 Old London Road (1864)

You may not have noticed the Grade II-listed old police station standing proudly behind the toppling telephone boxes, but for 104 years it was home to Kingston's police. When the station first opened there was an inspector, five sergeants, two acting sergeants, thirty-one constables and five horses. When it closed there were over 100 officers, bicycles, a Hillman

Above: A commemorative card depicting the finding of PC Atkins with a good sketch of The Knoll on Kingston Hill, long-since demolished.

Right: The old Police Station.

car and a Talbot van.[58] The five stables and the old hayloft above in the rear yard, which in recent years housed the corner restaurant kitchens, have just been demolished.

The building was designed by Charles Reeve, architect and surveyor to the Metropolitan Police and County Courts. Between 1843 and his death in 1866, he designed and supervised the construction of forty-four police stations and sixty-four new courts – on average, five buildings each year.

This station saw two tragedies. In 1870, Sgt George Robins was killed when he was kicked in the chest by his horse while practising mounted drill in the yard.

In September 1881, PC Fred Atkins (twenty-three) of V Division was murdered when he disturbed a burglar at the Knoll, Kingston Hill. He was making a routine check of houses following burglaries nights before. He was shot three times and found by the butler, who sent for help. His injuries were considered to prove imminently fatal and rather than risking the journey to the nearest hospital in Surbiton, he was taken to the police station where, before he died, he managed a few words: 'Before I was aware of anything I saw something like the gleam of a lantern, and then whispers, after which there was a report, and then I felt I was struck by something sharp in the chest. I turned to one side quickly, when another shot was fired, and that's all I can remember.'[59] Police diligently searched the grounds. Local blacksmith, and perhaps likely suspect, Francis Brockwell was soon arrested as he lived nearby and his boots were found to match footprints in the grounds of The Knoll, but he was later released. Atkins' killing remains one of only two unsolved police officer murders.

29. The Second Workhouse Infirmary, Coombe Road (1868, 1894)

As with Elmfield earlier, this is another building that people do not tend to look at due to its function. It is part of a hospital and understandably people have things on their minds other than the appearance and history of the building. I find it strange that this building is not listed as it is the only remaining part of Kingston hospital that dates back to the Victorian era and the time of the workhouse. It is not even considered as deserving of townscape merit.

A new workhouse locally known as the 'Grand Palace on the Hill' had been built in 1839 as the existing workhouse was overcrowded. It was designed for 320 inmates (that term again!).

In 1843, the first workhouse infirmary was built and was designed for 80–100 assuming, it seems, that the designer anticipated an illness or incapacity ratio of one in four, but

Entrance to the Second Infirmary. *Inset*: Carving over the door. The centre depicts the lame and the young being welcomed. Note the sheaves of wheat and the basket of bread.

as soon as it opened it proved inadequate and patients had to sleep on the floor due to lack of beds. As a consequence, the second workhouse infirmary, which we see today, was commissioned and opened in 1868 with eight wards and ten beds in each. The architect was Charles Luck.

The *Surrey Comet* declared it 'a decided ornament to the locality – the last word in modernity' for it had gas lighting and was heated by open fireplaces. Windows were provided on both sides of the ward to promote good ventilation, although whether this was considered as being beneficial to health or for another reason is not clear. Perhaps the fact that a 'dead house' was constructed in the basement with a sealed ceiling to prevent foul odours from rising to the wards above sheds a little light on the need for fresh air. The workhouse now held 344 inmates and there were 180 beds in the two infirmaries, resulting in a bed being available for every other inmate. Unfortunately, despite the building being the last word in modernity, there was still a shortage of beds as the *Surrey Comet* also noted that of the 344 inmates, no fewer than 260 were under medical care.[60]

Shortly after opening the new infirmary was, understandably, found to be filled with people, one imagines, sleeping on the new floor, and so plans to extend were immediately prepared. The new extension to the south of the second infirmary opened in 1894 and the two buildings today comprise the Regent Wing of Kingston Hospital.

30. The Keep, King's Road (1875)

The Grade II-listed 'Keep' was built in 1875 by Major H. C. Seddon to a standard model designed to alter the public image of the army and to promote the idea of the strength of the military. The crenulations and castle appearance had no specific operational or defensive purpose; the aim was solely to attract urgently needed recruits. The Keep was the gatehouse to the barracks and army store depot located behind. The building is listed as it is one of a few surviving keeps from an important national recruitment drive and, in the context of nineteenth-century military history, this is a building of special architectural and historic interest.

Army reform was brought about by the unnerving success of the Germanic and Prussian forces over the French in the nine-month Franco-Prussian War in 1870–71.

The German forces were not only superior in numbers but had far better training and leadership than the French and they made more effective use of modern technology, particularly railroads and artillery. The war proved that the German-Prussian system of professional soldiers, well trained and armed with modern weapons, was far superior to the traditional system of gentlemen soldiers that Britain used.

One of the more interesting lobbies for reform came from George Chesney RE, who was concerned over the ramshackle state of Britain's army and had written to the papers. But his letters had received no recognition, and he therefore resorted to an early form of science fiction to put his point across. He used fear and it struck deep into the heart and mind of people who had previously believed in the perceived invincibility of the Empire. In 1871, Chesney published *The Battle of Dorking* (ref: Project Gutenberg Australia) wherein Britain is invaded by a superior German force and the opposing forces meet outside Dorking with disastrous effects to Britain and its empire. References to the army coming from and returning to Kingston provides added local interest. The story helped changed opinion and

The Keep Gatehouse through which many brave men marched to the Boer War and the First and Second World Wars.

is today considered a founding piece of invasion literature, predating the plot of H. G. Wells' *War of the Worlds* by thirty years.

Despite the 'old guard' opposition, most notably from the Duke of Cambridge, the Secretary of State for War, Edward Cardwell, supported by Gladstone, achieved some success and reforms were passed.

Accommodation became the responsibility of the government not the county, and duration of service was reduced. The most significant change came when Regimental Districts based on county boundaries were created, allowing men to enlist knowing that they would serve with friends and would be housed in a particular county. A sense of belonging to an area was established and, as hoped, the changes saw an immediate increase in enlistment. Kingston became the barracks and depot for the old 70th and 31st Regiments, which in 1881 became known as the East Surrey Regiment – Kingston's Own Regiment. Kingston's Keep became synonymous with the town. Men marched through the gates of the Keep on their way to France. One officer, Captain Wilfred Nevill, took with him through those gates something he believed would, when the need arose, inspire his men.

The need arose just before dawn on 1 July 1916 at Contalmaison (near Amiens) when the East Surreys went 'over the top'; the Somme offensive had begun. Captain Nevill had given a footballs to platoon commandeers and suggested that they be kicked towards the

THE EAST SURREY REGIMENT.
Football on the Battlefield of Contalmaison

Spot the balls – there are two.

German lines. He urged his men to keep kicking the ball forward over the mile and a quarter of ground they had to cover in order to reach the German trenches. Nevill led by example and kicked before him a football on which he had written 'The Great European Cup Final – East Surreys v The Bavarians'. Within ten minutes of 'kick-off', machine guns had mowed down nearly 450 men sadly including Nevill, but still the footballs were kicked onwards. The East Surreys reached the German trenches. After the attack two balls were recovered and later returned with honour to the Regimental Depot at Kingston upon Thames.

In the First World War, Sampson tells us that more than 84,000 men marched to battle through the keep gates, of which nearly 7,000 were killed.[61] The East Surreys achieved sixty-two Battle Honours and had seven recipients of the Victoria Cross. In 1921 the Chapel of Holy Trinity was dedicated as the Regimental War Memorial of the East Surrey Regiment.

The barracks closed in 1959 and behind the impressive Keep today is a new housing development. So, when you next pass by the Keep, think of the brave men that marched through the gates taking with them thoughts and the respect of Kingston.

31. The Old Post Office, No. 42 Eden Street (1875)

The red-brick Old Post Office on the bend of Eden Street stands where, until closure in 1852, the Bridewell (or House of Corrections) and the county gaol were located, having incarcerated prisoners since opening in 1760. After the prison closed and inmates (again?) were rehoused in the new Wandsworth Prison, the site was purchased by the town council then sold at a profit to the War Department for their use as barracks.[62]

However, following the construction of new barracks, fronted by the Keep in King's Road, the site was divided with one half being retained for the War Department's use and the other allowing the construction of Kingston's first purpose-built post office, which opened a year later.

In 1887, the post office was handling 79,904 letters a week and 1,597 parcels (for a six-day week that's 13,300 and 266 each and every day).[63] Remember, letters were sorted by hand! There were forty-seven postmen and five prompt deliveries each day on what was, at the time, the Victorian communication highway. Surbiton and New Malden had four deliveries each day.[64]

To provide the service the building had to function efficiently, which is down to the design and staff. The building was designed by the Office of Works architect Robert Richardson, who also designed Putney and Chester post offices. There are a couple of features to note: the royal monogram with 'VR' and '1875' high up on the west-face gable, and the two carved beasts springing out from each side of the entrance doors. They have silently guarded the entrance ever since the building opened and deserve to be treated kindly – say hello when you see them.

In 1984 the sorting office moved to a mechanised service in Surbiton. Until then all Kingston post had been sorted into pigeon holes by hand.[65] The post office closed its doors for the last time in 1997. This Grade II-listed building is now part of a regeneration scheme and after refurbishment will provide a fitting reminder of the days before texts and emails.

The Old Post Office and entrance. *Inset*: One of the two 'guardians' over the entrance.

32. 'Boots Façade', Nos 15 and 16 Market Place (1882, 1909, 1929)

After 'Out of Order', David Mach's telephone box arrangement, the façade of this building (more correctly *these* buildings, as there are two), is in all likelihood the most photographed art form in the town. As much as I sincerely like, admire and appreciate the art and forgive the historical inaccuracies (which only time and later research has brought to light for those who follow Kingston's history), I find the façade of this Grade II*-listed building strangely unsettling, to the point of finding it unintentionally 'deceitful'. There is a lot to admire but when one delves into its history all is not what it seems. A trait, it appears, of many of Kingston's ancient buildings.

Most texts recount that the design of the façade is from a sketch by Alderman William Finny, seven times mayor who, when approached by Jesse Boot for an idea for the front of the new store, had a moment of inspiration and, at the end of a council meeting, sketched it on blotting paper. Jesse Boot is said to have liked the design so much that he told his architect and his sculptors to build it just as Finny had sketched it.

It's an engaging story and not one that Alderman Finny would have been likely to deny. But had anyone travelled to York, King's Lynn, Derby, Bury St Edmunds or Winchester they would have seen similar façades for the Boots shops there. I firmly believe that credit

The post-1929 façade.

Left: The original façade with five statues but Boots had yet to purchase the adjacent building.

Right: The stained-glass window, possibly by Finny, on the stairs. You would have seen this when going up to the first-floor Boots' Book Lover's Lending Library.

for the artwork and form belongs to Michael Vyne Treleavan, designer for Boots, and not Finny as the frontage is just one of sixteen black-and-white mock-timber-framed store façades built for Boots between 1903 and 1914. It clearly was a branding style as each shop had figures of local interest or importance arranged in a Tudor-esque setting. Finny may well have contributed by providing the history or parties to be depicted, but look at work by Treleavan and you decide.

The façade is unintentionally deceitful in other ways. For instance, it appears to be just one building and one design but two thirds were erected in 1909 and the final third, on the right-hand side, was added twenty years later.

Then there is the fact that the colour, detail and artwork subliminally convince you that this must be all that there is to see and so you move on, not once thinking that there might be something of equal, if not greater, interest inside. I urge you to ignore this thought and go inside; as you climb the stairs, not to be missed, is an impressive stepped stained-glass window romantically depicting the crowning of Edward the Elder, son of King Alfred. As Finny is known to have designed stained-glass windows for the Town Hall, now in the museum, I will give him the benefit of the doubt and suggest that he is likely to have had a hand in the design of the rear window.

When you get to the first floor and look towards the leaded windows facing out onto the Market Place, the room almost takes on the feel of a country house. It was designed to create such an impression. This floor was for members of a club that both middle and lower class could enjoy but which is an aspect of Boots that appears to have been long forgotten. It has absolutely nothing at all to do with being a chemist.

Imagine this first-floor area with wall-to-wall shelves of leather-bound books, chairs set out casually alongside occasional tables, and potted plants on the window cill. You came to this floor for one purpose only: to look for a book that you wanted, and you could either take it with you or sit in splendour in the middle of Kingston and read.

This was designed from the outset to resemble the library of a country house and was set aside solely for the members of the Boots' Book lover's library, a subscription-based service.[66]

Returning outside, I find the façade deceptively draws your eyes away from the surrounding buildings, which are honest and rightfully deserve your attention. I certainly admire the façade as a work of art but look around you and see what else you have been missing.

33. Surrey County Hall, Penrhyn Road (1892–93)

Have you ever pondered on the origin of certain street names? For Penrhyn Road, you have two options as to who it was named after: Alfred Higgs, a chemist and dentist who faithfully served Kingston for more than forty years, or Edward Leycester, son of an MP, a Royal Surrey Militia officer and the first chairman (of many) of the Council Committee but who didn't live in Kingston. Guess who they chose?

The Surrey County Hall

The Local Government Act (1888) took administrative functions away from local magistrates, who were not answerable to the public, and passed them on to county councils. These were to be formed of publically elected councillors and selected councillors chosen by the elected councillors. For the first time a member of the public could be a councillor. You can imagine how that sat with the established clique of the previous administrators who tended to be landed, titled or in a position of status and importance.

Early in 1889, Surrey County Council convened the first ever meeting of 'elected councillors' held in Britain. The venue chosen, naturally, was the Session Court House in Newington, near Elephant and Castle, where the previous administrating magistrates sat for the quarter sessions. But there was a problem: Newington was no longer in the county of Surrey, rather like Kingston today. This opened a debate as to where future meetings should be held and a battle began between Guildford, Wimbledon, Epsom, Reigate, Redhill, Kingston and Little Bookham. (No, I have no idea why Great Bookham didn't apply.) A special committee decided on Wimbledon but this wasn't accepted and a ballot was held in which Guildford beat Wimbledon and Kingston. Wimbledon protested, demanded a recount and Kingston won.

The choice of the architect for the new Surrey County Hall epitomises irony. Charles Howell was principal architect of lunatic asylums in the Victorian period but as he had been the county's surveyor since 1860, he was selected. A site was chosen, this being part of an estate called Woodbines adjacent to Grove Road, running between Kingston and Surbiton. The site cost £4,000 (£331,828) and £41,964 (£3.5 million) to build.[67] In June 1893, the *Surrey Comet* referred to it as the 'palatial structure in Grove Road'. Much was made of the fine sculpted carvings over the windows of the Grand Hall where representations of Law and Liberty, Justice and Mercy and Peace and Plenty complemented the court, grand jury room, council chamber and committee room behind.[68]

The building opened on 13 November 1893 but, rather than having a planned and dignified procession, there was farce. The mayor arranged a lunch for the council and honoured guests but midway through the meal word spread that there were no reserved seats in the council chamber. This led to an undignified scrambling to County Hall. The Surrey Comet reported of 'Many, including peers and usually sedate country folk, running the distance in a manner more energetic than fitting.'[69]

When all had arrived and were seated, the council chamber was flooded with electric light – the first public building in Kingston to be lit in this way.

The building was extended in 1930 and again in 1938, the later extension being damaged by a 'flying bomb' in July 1944. Further extension and refurbishments have taken place since.

Early this century plans were in motion again for the council to leave Kingston for Woking but the executive committee decided to stay in Kingston.

It was decided to rename Grove Road in which the new County Hall now stood. They chose to name it after the first chairman of the county council, Edward Leycester-Penrhyn (did you guess?). But Penrhyn was not even the family name; a relative bequeathed a fortune (£6 million) to Edward's father on the proviso that he assumed the name.

Finally, what of Alfred Higgs, the dentist and chemist of No. 42 Richmond Road? When for the first time, in 1888, the opportunity for a member of the public to be an elected

councillor was presented he put himself forward as a candidate. The position of an elected councillor was considered by the *Surrey Comet* as 'an honourable one, and carry with it a corresponding importance and influence which will make the seat a thing to be desired in itself, irrespective of the inward satisfaction which public service should bring to every well-ordered mind.'[70] The *Comet* continued: 'We can scarcely credit that Mr Higgs is so puffed up with vanity … as to imagine himself a fitting representative of the town on the county council.'[71] Spurred on by the article, an effigy of Alfred Higgs was mounted on a cart and dragged through the town to jeers of contempt. He came last in the poll and went back to looking after people in the town.

Dear councillor, please right this wrong and let's have a Higg's Close somewhere to commemorate the first member of the Kingston public to apply for office.

34. Nos 3 and 5 Thames Street (1901)

'In all matters of a public character the Nuthall's [*sic*] are ever to the front, and their names are associated in many ways with the best interests of the town. It is therefore by no means surprising that they are so universally respected both in business and private life, and honoured by the friendship of many notable persons in high positions.'[72] This quote, from a trade directory ten years before this building opened, shows the true respect that the Nuthall family held in the town and all walks of life.

The family supplied the town and further afield with confectionery, wines, tobacco, cigars and, of course, tea, which had been the original source of their success. They had two shops in Thames Street – a wholesale confectionery department supplying local retail outlets and a wine store in town – and vaults in Broad Street, London.

Charles Nuthall (a confectioner, refreshment contractor and wholesaler, retail wine and spirit merchant) occupied No. 3; at No. 5 was his cousin Alfred, dealing in tea, coffee and tobacco. In 1898 they decided to merge and so commissioned local architects Carter & Ashworth of Eden Street to design an establishment that would be the last word in style and service. They did and it cost, in today's money, over £2.4 million. The style is apparently 'New Renaissance' but many call it the 'Dutch building'. Under its Grade II listing it is noted as being an 'elaborate Jacobean, three-tier gable with applied Ionic columns and broken "scroll" pediment'.

The *Surrey Comet* reported, 'The premises are entered through an imposing portico, supported by six handsome pillars of coloured granite … right and left of the entrance are the spacious shops for the retail business and in the centre is the corridor leading to the Knights' Room, used as a luncheon and dining room and leading out of it is the Roseberry Room, which overlooks the river, used for afternoon tea, banqueting and as a ballroom, its beauty is a constant subject of remark.'[73] At the first floor was King's Hall, with mirrored walls and carvings of fruit and corn on pillars picked out with gilt. Doors led onto the terrace overlooking the Market Place. On the second floor was a court room, a Masonic room and individual private supper rooms. It was Edwardian elegance and splendour run by William Nuthall, one of Charles' nephews. The business eventually failed due to shortage of supplies in the war and unsustainable costs in the Great Depression. In 1932, it became British Home Stores and has remained a shop ever since.

Imagine pre-war Edwardians and post-war 'flappers' of the '20s standing on the terrace in front of the first-floor windows looking out and down to the Market Place below.

35. The Gazebos (1901)

These Grade II pavilions were originally part of the riverside gardens built with Nuthall's Restaurant and have the same terracotta stonework surrounding the landing stage, as on the restaurant façade overlooking the Market Place. The weatherboarded lower floor of each pavilion is divided by pilasters into two bays per side and the open loggia above has square, half-fluted columns supporting a pyramid-shaped roof topped by finials.

There is no definitive answer to the question 'Why are they here?' and what you see today is not how they were, as Edwardian postcards reveal that the lower sections had windows. Being associated with the riverside garden, it seems likely that they could be hired for a private tea party.

The tale that the Gazebos were specially built for the use of a Japanese dignitary who then didn't attend is simply a story. It may have arisen from the fact that in 1902, to celebrate the bicentennial of Queen Anne's accession, the Market House statue was regilded and resident minister for the Japanese Empire, Viscount Hayashi, living on Kingston Hill since 1900, was invited to unveil the statue on St George's Day. Nuthall's Restaurant was due to finish in March but it may have been late and, of all the things that could be left to the end, the gazebos seem a likely choice. They may just not have been ready for Hayashi who, for the record, did actually attend.

The two pavilions that originally had windows at ground-floor level.

36. Kingston Public Library (1903)

With all seriousness and urgency, there are two idioms that apply to you here: 'If you don't use it, you will lose it' and 'You never miss the water until your well runs dry'.

Kingston was the second place in London to adopt the Libraries Act, and in 1882 the first public library opened in the former Wesleyan Chapel, St James's Hall. However, public demand meant that the hall was too small and, in 1891, the library moved to Clattern House. As is always the case, whether it be hospital beds at the workhouse or books at the library, once you create a space it is filled. The library committee agreed that they needed to relocate again but to a permanent location. In 1899 a suitable site was identified and a loan of £474,222 (today) was raised to fund the design and construction. A design competition was held and the successful design produced by architect Alfred Cox, who was engaged. The building cost was not covered by the loan but, fortunately, further money was donated by Andrew Carnegie, at the time the richest man in the world. Carnegie opened this, your free public library, on 11 May 1903.

The library, in front of which stands a twelfth-century pillar, rescued from a garden close to the Clattern Bridge. Its origin is unknown. Could it, perhaps, be a part of the old Norman western entrance to the church, which was rescued from demolition and erected in a garden overlooking the Hogsmill River?

37. Kingston Museum and Art Gallery (1904)

The museum and art gallery follows the library as the two are linked by location, appearance, social importance and by Andrew Carnegie. During the celebration dinner that followed the opening of the library, it became readily apparent to Carnegie in his discussions with the mayor and others that Kingston had not been able to fulfil its heart's desire to have a combined library, museum and art gallery. He therefore increased his gift by £6,400 and thanked Kingston for its hospitality and wished them well with the museum and gallery which, as a direct result of his donation, was built as planned and opened on 31 October 1904.

The same idioms apply here and if you haven't been recently, or ever, you are missing an absolute hidden treat. You will find your own favourites, but ask to see Thomas Abbott's vase and the Muybridge collection and you will be hooked and talk about it for days. But there is just so much more! When can you go?

The museum and art gallery, with three empty niches for statues or perhaps busts that have never been filled. Surely something could be displayed in the same way that the fourth plinth is used in Trafalgar Square, after all this *is* an art gallery.

38. The Old Kingston Telephone Exchange, Ashdown Road (1907)

Telephones came to Kingston in 1893 when a converted villa at No. 23 Fife Road became the first manually operated exchange serving the National Telephone Company. In 1902, the Post Office opened a rival exchange in its Brook Street premises and then, due to growing demand, commissioned the demolition of the old army drill hall and the design and construction of Kingston's first 'purpose-built' telephone exchange, which opened in June 1908. John Rutherford, an architect in the Ministry of Works, successfully integrated his arts and crafts style with the nearby post office built thirty-three years earlier.

Rutherford had an impressive design portfolio and one need only look at his post office designs prior to Kingston's New Exchange to see what he would produce. Consider Weymouth (1905) and Liverpool North (1906); each are on a corner with a butterfly plan design, as we see at Ashdown Road, with a central entrance between two perpendicular wings and gable ends.[74] The squared entrance at Kingston with a central clustered brick and stone chimney maximises the internal space in the two wings. His use of local red brick and stone facings complements Richardson's earlier post office design.

The Grade II building is being renovated as part of the Post Office site regeneration. I wanted to draw your attention to Edward VII's insignia in the iron railings but, as part of the works, they have been removed. I hope that they will return.

The double-gabled infilled entrance and central chimney stack. *Inset*: The black Shrubsole link in the mayor's chain.

The exchange was built on the site of the old drill hall that remained following the army's relocation to their new barracks in King's Road. The hall was spacious enough to house 2–3,000 and, understandably, was used for public entertainment.[75]

Bellars tells of the drill hall being the venue for the annual 'Sparrow's Dinner' where 500 children, often selected from poor families, sat at five tables and were served a roast beef and a plum pudding dinner, after which they had a concert and received gifts of sweets and fruit donated by town traders.[76] Such charity dinners were often attended by the mayor. On 15 June 1880 thrice mayor of Kingston, Henry Shrubsole, presided at the annual dinner given by the townspeople for the poor. He had just finished addressing the meeting and was in the act of presenting a packet of tea when he fell forward and died.

Public donations led to the erection of a water fountain at the end of the Market Place although the inscription incorrectly records the date of his death as 18 June 1880.[77] If you ever happen to see the mayor wearing the Chain of Office have a look at the back and notice the black link that commemorates the death of Shrubsole while serving in office.

39. The Old Empire Theatre, Nos 153–61 Clarence Street (1910)

On the evening of 24 October 1910, a bright light shone out over the rooftops of the town. It could be seen from all approaches to Kingston and visually announced that something spectacular was happening. It was opening night at the Empire Theatre. The light shone from the illuminated dome, the Empire being the only theatre in the country other than the Coliseum in London to have such a welcoming beacon. This was the 'special feature' designed for the theatre by experienced architect Bertie Crewe.

It was his eighteenth theatre and having been commissioned for three 'Theatre Royal's, five 'Hippodrome's and for Sadler's Wells, he knew how to set out and design a stunning theatre, but he also wanted the façade to be impressive. Combining red brick with terracotta to add Portland stone, he referred to this style as 'Modern English Renaissance'. I have to admit that, for me, this means nothing and is simply a phrase. Nuthall's Restaurant façade is said to also be in the 'New Renaissance' style.

Opening night brought more than just the 2,000 audience members to Clarence Street. People stood to watch the spectacle and others hoped to get tickets for the later performance. The theatre was 'Packed, Pit to Ceiling', which became the theatre's catchphrase for years to come as every variety performer of note 'played' at the Empire.

The design of the auditorium was such that there was an uninterrupted view from all the 'tip up' seats and there was plenty of knee room. At circle level there was an impressive 'promenade' behind the seating from which spacious lounges were accessed. Two private boxes on each side of the stage provided for those who desired to be separated from the hoi polloi of Kingston.

In addition to leading variety stars, the theatre also served a touring circus with lions, tigers and bears caged backstage. However, the elephants had to be stabled in Acre Road and would be seen daily being led along Richmond Road to the large stage equipment door. When it was dark they had red lights on their tails.

Audiences declined after the war and the theatre closed on 27 March 1955. It is often said that TV killed theatre so it is interesting to note the view of Olly Aston, musical director between 1934 and 1949, who said: 'It was the laziness of the artists that killed it. Big stars were coming to the Empire regularly and bringing the same material with them. They couldn't be bothered to change their acts or even attend rehearsals.'[77]

The Empire Theatre, without its illuminated dome, looking toward Nipper Alley, which is what the HMV dog is named after, who sits on his master's coffin, his head tilted quizzically as he wonders how he can still hear his master. Nipper was buried in a garden that is now the car park at the rear of Lloyds Bank in Clarence Street.

After it closed and Kingston Council lost the opportunity to buy it, the theatre was sold on and the interior was gutted. A year later, in 1956, it opened as a supermarket and subsequently the ground floor was converted into a pub.

The current pub chain presents as caring about the local area and history of the towns they serve by having old photos of the area adorning the walls. Upstairs is occupied by a local church. The two tenants are strange bedfellows but the building is in good hands.

Surprisingly, the Old Empire Theatre is another building that has no current listing.

4c. Sopwith House, Canbury Park Road (1917)

If you had to pick just one place in the world that played a major part in the Allied victories of both world wars, where would you pick? Many will say 'the United States' forgetting that, if it hadn't been for the bravery and success of the RAF in the Battle of Britain, our island would have been invaded by Germany as predicted by Chesney, long before the USA entered the war.

Unlikely as it may seem, Canbury Park Road is the place I would pick. This Grade II-listed red-brick building with its bay windows played a vital part in the Allied success in the first of these world conflicts. This was the factory and offices of the Sopwith Aviation Co. from which came 25 per cent of all the British planes of the First World War and 60 per cent of all British single-seat planes.

It was soon realised that aerial reconnaissance was vital and far more productive than ground-based cavalry or static balloons. Each side took to the air and in the early, gentlemen-pilot days, British and German spotter plane pilots would wave or salute each other. The high command decided that waving, as with playing football on Christmas

Tommy Sopwith's office was on the first floor with bare wall and bay windows.

Day, was not in the spirit of warfare, so reconnaissance pilots started shooting at each other, giving rise to the fighter plane. Whoever controlled the air would have the advantage of knowledge of the other side and prior knowledge of enemy intent is what wins wars. Britain very quickly needed planes – lots of them, and as versatile in design as possible.

Reconnaissance planes, fighters and bombers all came from here. No other site in Britain saw the design of so many outstanding aircraft as this one: Britain's first flying boat; the first plane to destroy a Zeppelin; the first fixed-gun single-seat fighter; the first plane to land on a moving ship; the first tri-plane (later copied by the Dutch Fokker company); the Camel, which was the most successful Allied fighter in the First World War; and the Snipe, the best fighter of the First World War. After being designed and manufactured here, they were each then taken to Brooklands airfield for testing.[78]

Their chief test pilot was Harry Hawker. Born in Australia, the son of a blacksmith, by the age of eleven he was working in a garage, earning money by helping to build engines. He qualified as a mechanic and became a chauffeur, then in 1910 decided to come to England to become involved with aviation. In 1912 he became a mechanic for the Sopwith Aviation Co. and, having persuaded Tommy Sopwith to teach him to fly, made his first solo flight after only three lessons. A month after obtaining his pilot's licence he won the Michelin Trophy for endurance after flying for eight hours and twenty-three minutes.

After the end of the First World War, Hawker, Sopwith and two others contributed to the foundation of a new company, H. G. Hawker Engineering. Sopwith didn't mind; he said that Hawker was largely responsible for growth during the war. Hawker was killed in an air crash in 1921 and the king sent a message of condolence, asserting that 'The nation had lost one of its most distinguished airmen'. He is buried at St Paul's Church, Hook, Surrey.

After the building closed as an aviation factory it became a polytechnic and then a university engineering department. Now residential, one wonders if the residents know that the world from 1917 would have been very different were it not for what took place in this building and on this site. The Sopwith factory was, undeniably, instrumental in obtaining vital information and, at the same time preventing Germans from obtaining equivalent information and thereby has to be considered as being key to the Allied success in the First World War.

41. The Old Regal Cinema, Nos 22–30 Richmond Road (1931)

Whatever people say about the one-way system, it serves to fulfil the wish of architect, Robert Cromie. It is only now, as you approach the Grade II-listed building along Sopwith Way that you can truly appreciate the façade and see the architectural detail of the old Regal Cinema. You may think it is just an old red-brick building that used to be a cinema, or home to Gala Bingo, but look again (or at least when the current scaffolding is removed as it is currently being converted and so is temporarily hidden behind screened scaffolding).

It is not just a plain brick wall with exit doors, although that is how people tend to describe it. At ground level there is a continuous stonework band to door height, above which is brickwork. But even then, set into the brick façade facing onto Richmond Road are four art deco niches, each stepped up as if on a plinth. The niches' windows provide daylight to the stairs leading down to the exit doors beneath. Over the main entrance are four Ionic columns between which are recesses housing windows, the curved simplicity of the columns separated by floral decoration at the top of the niches.

Cromie's entrance (currently being renovated).

When originally listed, this building was considered an early and well-preserved example of an art deco cinema from the 1930s and a good, rare example of the work of Cromie – a major cinema architect, many of whose designs have not survived. Sadly, despite the inclusion of 'rare' in the listing, the building has suffered internally as a previous owner seems not to have cared about heritage, and this led to significant internal damage and destruction. That said, the building is undergoing a refurbishment and we shall soon be able to admire Cromie's exterior once again. Coincidentally, in 1909, Cromie entered the office of Bertie Crewe and may well have helped Crewe's team working on the Empire Theatre.

The Regal opened on 15 February 1932 on the site of the 1909 Cinema Palace, the first purpose-built cinema in the town. That night, audiences were treated to *Splinters of the Navy*, a British comedy made at Twickenham Film studios; *Keepers of Youth*, a drama based on one of thirty plays written by Arnold Ridley (who played Private Godfrey in *Dad's Army*); and *Our Wife*, with Laurel and Hardy. Prior to the films and during interludes between them, the audience was treated to the Grand Wurlitzer organ rising as if by magic from the floor and then, as the curtains were drawn back to reveal the screen for the next film, it would descend with the organist still playing, who would give a little wave before he disappeared into the orchestra pit. This fabulous organ can still be seen and heard in the Musical Museum at Kew Bridge.

The building was required to be versatile and in addition to presenting films, Cromie designed it as a theatre (perhaps a result of Bertie Crewe's earlier influence at the Empire) and it was home to stage shows and radio broadcasts. It still contains a hidden gem: the original tearoom now used as a dance studio. It is a five-bay hall with a sprung floor, and a full-length seating area behind that is separated by fluted square columns, mirrors in art deco 'fountain' motif surrounds, and a small stage. It is considered a rare example of 1930s art deco and is even preserved in its original colour scheme.[79]

Yet another hidden gem and a further tearoom-cum-dance hall

In the mid-1970s, cinema audiences declined and the Regal, known from 1960 as the ABC, closed and became a bingo hall, which in turn subsequently closed due to the lack of a full house.

42. Bentall's Wood Street façade (1931, 1935, 1992)

This is the second wall of note in Kingston. It looks like a building and, sure enough, there is an interior behind it, but the outer wall predates the interior by sixty years or so and is, apart from the restored art deco Wood Street entrance, all that remains of the Bentall's store of the 1930s. Its Grade II-listed English baroque style is derived from the Sir Christopher Wren rear extension to Hampton Court Palace. Usually the architect (Maurice Webb) gets the credit, but this is not the full story and I believe credit should be attributed to one man, Leonard Bentall. In 1974 his son Rowan recalled:

> My father had always been an admirer of …. Wren's work on the William and Mary wing of Hampton Court Palace, and he was determined that the façade of the new store would take its inspiration from this…… He wanted a classic building that would still be up-to-date in a hundred years'. He continues 'The eminent firm ….Sir Aston Webb and Sons were initially taken aback by the nature of the Bentall's commission, but they threw themselves into the immense task with great enthusiasm.[80]

Above: Bentall's Wood Street façade.

Below left: The 1930s postbox for you to find.

Below right: Elaborate carved keystone over the doorways.

There are subtleties in the design. The façade is arranged symmetrically in bays so that at each end there is an arched doorway with fabulously sculpted keystones at street level and the window head above it is corniced. Then there are seven windows where the head detail is a simple stone lintel before the three-bay, stone centrepiece that was built as a Greek temple frontage, with paired Corinthian columns and a pediment. An oft-overlooked detail at ground floor is the 1930s postbox set in the wall – I'll leave you to find it!

The new store was built by John Mowlem & Co. and was comprised of two phases, allowing the store to transfer its operations to the new building as its old premises were demolished.

The first phase included the Wood Street façade and the main shop floors behind. It opened on 19 November 1931 but with little ceremony. People entered, as they do today, through the semicircular Wood Street entrance lobby, designed by Ferdinand Chanut, which, despite some later 1992 renovation, remains in appearance very much as it was. Two clocks just inside the lobby entrance originally told the time of day and the 'lighting up' time.

When nearing completion, the new store behind the façade was just an empty shell needing to be filled, a costly exercise at any time and especially during the depression. The phrase 'one man's loss is another man's gain' can hardly be better illustrated than by the fortunes of Eric Gamage and Leonard Bentall in June 1931. Gamage looked to open a new store in the West End, close to Marble Arch and Selfridges. After six months the venture failed and the building and contents were to be auctioned with the proviso that if there was no bidding for building and fittings, then the two would be split into separate lots. Bentall put in a bid of £65,000 (£3 million) for just the stock and it was accepted.[81]

The first phase continued trading for the next three years during construction of the second phase, the south-west curved corner, which opened to fanfares on 9 September 1935. It was all a far cry from the small draper's shop opened under the new management of Mr Frank Bentall on 20 July 1867, when takings on the first day were £41 2s 6d (£2,600).[82]

In 1990–92 the entire Bentall's site was redeveloped with the exception of Webb's façade, which was retained as part of the frontage to a new indoor shopping complex known as the Bentall Centre.

43. Siddeley House, No. 5c Canbury Park Road (1933)

In 1940 Germany looked to invade Britain, the last major power in Europe standing against the Nazis. If they controlled the air, Britain's navy could be bombed. It was as simple as that: win the air and the invasion could begin. However, working in this small Grade II-listed red-brick building, directly opposite the old Sopwith factory, there was an aircraft designer called Sydney Camm. Sydney had joined Hawker Engineering in 1923; this building was their 'Experimental Workshop' and opened in 1933. The two were made for each other.

Having become chief designer in 1925, Camm had started on an Air Ministry tender for a monoplane fighter. Alongside him was Sopwith's chief engineer, Fred Sigrist, who had been responsible for the successful engineering and production of Sopwith's First World War planes.

This was a self-contained building of design, prototypes and secrets and opened in 1933. One such secret was Camm and Sigrist's design to reduce weight and avoid risk of welding failures, by developing a technique using steel-tube frames that could be bolted together. By using wood, canvas and aluminium in the skin, they knew they could reduce and also spread the weight.[83] A lighter airframe meant a faster plane.

Camm sketched monoplane concepts around the fuselage design of his 1931 biplane, the Hawker Fury, which was in production and was the first biplane in the RAF to exceed 200 mph.

In 1935, using the Fury as a template but modifying the wing design to create a monoplane, he designed the prototype of the Hawker Hurricane. His design in this building changed world history. The Hurricane would become the RAF's first 300-mph aircraft and the workhorse of the RAF during the Battle of Britain.

Using the Hawker Fury construction line, the Hurricane could be introduced relatively easily whereas the Spitfire production line had to be fabricated almost from scratch. The Hurricane's framework design also meant repairs could be made expediently, enabling the fighter to return to the sky at the earliest opportunity.

Sopwith took a big gamble, but his decision too can be considered as a key moment in the war. He went into production of 600 Hurricanes without having received an official order from the Air Ministry and so, when it became clear that war was inevitable and an order was finally placed, there were already 600 Hurricanes in construction. Perhaps the significance of this is lost today but every single fighter plane was vital to the chances of Britain's success in the Battle of Britain. Were it not for Sopwith's risk in going ahead with production, the Germans would have inflicted far more damage and almost certainly would have succeeded in their intent to destroy Britain's south-east airfields. No airfields would have meant loss of aerial superiority and invasion would definitely have followed. Chesney's story of eighty years earlier would have become science fact.

On 15 September 1940, considered to be the pivotal day of the Battle of Britain, the RAF had 192 Spitfires and 389 Hurricanes. Now subtract from those numbers Sopwith's 600 Hurricanes as if they hadn't been made, pending a Ministry order, and Camm's and Sopwith's importance to Britain should fly out of the page at you.

This unassuming building also saw the design of the Hawker Typhoon, the RAF's first 400-mph fighter. If you get an opportunity to look inside, just behind the door is the original hoist and pulley on gantry. This would have lifted the prototype Hurricane and Typhoon.

You may have thought that Canbury Park Road was nothing special but stand with the Sopwith factory on one side and the Experimental Workshop on the other and you have, here in Kingston upon Thames, two buildings that undoubtedly changed world history.

The Experimental Workshop from which came the Hurricane, which helped preserve British ideals and standards and provided this country with its 'freedom'. Sadly, seventy-five years on there is graffiti on the shutter. Take a step back and think. 'For your tomorrows, we gave our todays.'

44. Guildhall (1934/5)

After 1840, Kingston kept growing due to the railway and a general increase in population, and as a consequence, more administration was required. Henman's new Town Hall soon needed to be supplemented by other offices, which were located here and there throughout the town.

In 1933, the decision was made to build a new Guildhall and, it appears, to source the materials from Britain or the Empire. The red bricks came from Oxshott, stone from Portland and tiles were made in Cranleigh. Timber comprised: Tasmanian Myrtle, a rich-red finishing or veneer timber; Australian Jarrah, a Eucalyptus of the Myrtle family; Teak; Australian Silky Oak; and British Columbian Pine.[84] Makassar Ebony, which grows in Indonesia and not in the Empire, was also used.

The foundation stone was laid in 1934 and the building took nine months to erect. Credit, if that is the correct word, is due to Maurice Webb for this one but as to its architectural style all I can say is that most references skirt the issue. The only mention I have found is that it is 'contemporary'. That said, it is Grade II listed and

Above: The Guildhall looking toward the mayor's chamber, the window of which should be somewhat obvious.

Below left: A fabulous art deco sculpted depiction of the Thames (note the flowing hair) and the three salmon that represent Kingston upon Thames. In 1087 the Domesday Survey recorded that Kingston had three fishing weirs and these much later gave rise to the three salmon seen around the town.

Below right: Hope (with the anchor) and Plenty (with the cornucopia) over the entrance doorway.

yet the old Empire Theatre is not. Personally, I think the tower is oppressive and needlessly dominates the building and this end of the town. As for the entrance and the Corinthian columns and pediment, why are they there? Perhaps they had spares from the Bentall's façade.

Beauty is in the eye of the beholder and so, despite my reservations about the tower, I find the art deco keystone depiction of the Thames over the entrance window, with her flowing hair and the three salmon, truly admirable, along with the fruit-laden barges and horses each side of the door and the Walter and Donald Gilbert classical sculptures of Hope and Plenty on the door. Each, on its own is well worth seeing.

45. Bentall's Depository (1935/6)

Another listed Maurice Webb design, but just look at the difference. Along with Henman's Market House and Bentall's façade, this Webb building represents Kingston. Its Italianate style, art deco detailing and bold colour combination of green on white makes it a landmark building fully deserving its Grade II listing.

Built on the site of Austin's jam factory the building is a landmark and, as Rowan Bentall describes, 'It was six storeys high with twin square towers and, at 109 ft. (33m) one of the tallest in Kingston.' He adds 'In case anybody should overlook it at night the name Bentalls [sic] appeared on the towers in green neon-lit letters three feet high.'[85] Inside nothing was left to chance and client and architect interaction enabled features to be incorporated to ease furniture handling and prevent damage from fire, damp and poor ventilation.

When a store van arrived it could drive straight into a lift and be taken to the designated floor to unload or load, the aim being to ensure that the furniture was handled as little as possible between the trusting customer's home and storage. Just imagine, vans rising six storeys in a lift in Kingston. Can you think of anywhere doing that today? This was before the war.

To prevent fire, no wood was used internally; every corridor had thick steel fire doors which were electrically operated and hydrants, hoses and chemical extinguishers facilitated fire suppression, if ever required. It wasn't!

Damp was prevented by 'designing-out' the potential for water ingress. Eaves were designed to overhang by 5 feet; external walls were 'hollow' and protected by plaster; flooring was concrete and windows all had their own guttering running into pipes inside the building connected to the vertical rainwater pipes. Ventilation was carefully regulated and to maintain an even temperature in summer and winter, the roof was insulated with cork.

Rowan Bentall tells of one final risk that his father, Leonard, and Maurice Webb, wished to avoid: that of 'human interference'. The corridors were therefore sunken 4 feet below the level of the storage space, thus placing furniture out of danger of being knocked by a passerby.[86] In 2000 the building was converted and is now part of the Rotunda complex and, though it has Odeon on the tower, the proud and innovative name of Bentall's is still to be seen, and rightly so!

The retained green-on-white appearance remains simple but eye-catching and the 3-feet-high Bentalls name remains looking out over the town. *Inset*: This art deco depiction of a deity in charge of security cannot be Securitas as she was a goddess.

46. Surbiton Station (1937)

This is, in fact, the third rail station in this area, two of which have been called Kingston Station and two of which have been called Surbiton Station – confused?

There is a lot of confusion associated with the early days of the station and the new town it spawned. But to simplify, the station was always called 'Kingston' from the outset until it subsequently changed to 'Surbiton'. It was never called anything other than these two names. The town on the other hand was initially known as Kingston-on-Railway, then Surbiton, Kingston-on Railway and finally just Surbiton.

The first Kingston Station opened in 1838 in a cutting just below where South Terrace is today. There were three pairs of tracks but the building comprised a single hut and 'platform' by one track. It appears one could get off and on heading 'down' from Nine Elms toward Woking, but it is not clear how one boarded going 'up' to town.

In 1840, a new, larger station was constructed on the current site. Sketches indicate that it had a railed courtyard. In 1857, these railings and the lockable gate rise to a wide-reaching legal case, Marriott versus the London and South Western Railway. Marriott ran an omnibus company from Twickenham station to Kingston station but

Surbiton Station with, perhaps, just a hint of Maxwell Fry?

had found the gates were regularly and deliberately closed to his buses, meaning that his passengers had to walk, with their luggage, to and from the station entrance, whereas buses from Mr Williams' Griffin Hotel in Kingston-on-Thames were allowed to enter the courtyard.[87] I could tell you the outcome and the effects on bus companies but isn't the fun in searching?

In 1936, the second Surbiton station needed to expand and Southern Railway's chief architect, James Robb Scott, was chosen. His white concrete with little embellishment, Grade II-listed, modernist design looks as visually stunning today as it was at the time. A photo really doesn't do it justice so you will just have to look inside at the wonderful pre-war detailing. For lovers of modernism this building is as much of a 'must-see' as is Edwin Maxwell Fry's Miramonte in Coombe. Coincidentally, Fry worked for Scott at Southern Railway and so one has to wonder if he was, in any way, involved with this design.

47. John Lewis Store (1990)

To the people of Kingston, although it has been here over a quarter of a century, the John Lewis store is still a comparatively 'new kid on the block'. However, for the store itself it is fast approaching fifty years since they expressed a desire to open 'south of the Thames'. In the early 1970s John Lewis looked at the Horsefair site but said 'neigh' due to the onerous traffic congestion.[88]

Ten years passed and despite positive discussions the development stalled until the late 1980s when Kingston Council was able to implement its relief road and pedestrianisation schemes. Traffic congestion eased, Kingston was now the place to be and, finally, the long-awaited deal

In 1864 John Lewis opened his own small drapery shop, John Lewis & Co., at No. 132 Oxford Street (later renumbered), on part of the same site as the present John Lewis department store. It is fitting (no pun intended) that two stores founded by drapers stand opposite each other in a town where Woollen Drapers were one of the four earliest trading guilds.

to build the store was made. Even then the construction faced difficulties both physical and man-made. Physical difficulties were caused by the proximity of the river and the man-made difficulties were due to the site being in one of the oldest parts of the town, where archaeological interest was high.

 The work started in September 1986 and, as expected, the construction scored direct hits by exposing the stone foundations of the original twelfth-century, or perhaps earlier, bridge and a merchant's fourteenth-century cellar that was known to be in the basement of an old pub, which was due to be demolished.

 With a feat of great engineering and teamwork, the contractor John Mowlem and Co., working with architect Paul Koralek of Ahrends, Burton and Koralek, Kingston Corporation and English Heritage, the undercroft was encased and removed and the old foundations were protected. The designers and John Lewis incorporated the foundations in the new basement, and so today we have one of the earliest buildings residing and being an integral part of one of the most recent.

 The store opened on 11 September 1990 with a Waitrose in the basement, the first time that both public faces of the John Lewis Partnership were housed in the same building. In October 2013, a multi-million-pound refurbishment was completed resulting in ground-floor expansion of departments including beauty, fashion and gifting.

48. The Bentall Centre (1992)

Admit it, you always say the Bentall's Centre don't you? Me too! In 1987 work began on the centre and in a repeat of the principle adopted for the 1931 construction, the task was to enable Bentall's to keep trading while the old store was effectively gutted and a new shopping centre built in its place. As before, careful phasing saw the new Bentall's store constructed at the north of the site. When this opened for trading the second, more elaborate, phase commenced whereby the whole of the 1932–35 building, excepting the wall, was demolished and the new shopping centre *was* constructed.

Kingston's 'cathedral'.

Above: The link bridge.

Below left: The link bridge detail.

Below right: Three Salmon – but look at their eyes and the jewel in the crown when you visit.

The height of the roof of the centre from the lower shopping level is taller than the dome of St Paul's or the nave of Westminster Abbey. This is particularly apt as the building was designed by architect Richard Allen to resemble a cathedral and has a nave, aisles, columns, transepts and modern stained glass over the entrance. It is Kingston's cathedral.

Is this just me or does the floor pattern look like old movie film frames with notches for a camera sprocket? Is this a nod to Muybridge or just a coincidence?

As for that long escalator, the one that reminds you of being on the best ladder in the game of Snakes and Ladders – you know, the one that goes right up to the top row. It is the world's longest escalator span between only two fixed points, top and bottom. Talking of construction, when you next look at or cross the link bridge consider that it was made in one piece in Germany and was floated by barge down the Rhine, across the North Sea and up the Thames, passing under all the bridges to Kingston. Then, overnight it was hoisted into position. Take a moment and look at the design as it is a work of modern art.

49. The Rotunda (2002)

The Rotunda epitomises the change in culture and entertainment in the last thirty years and it is somewhat fitting that it stands on the corner where not so long ago there stood an old cinema officially called Studio 7 but which people referred to as the 'fleapit' (and they weren't being affectionate!)

The site of the old fleapit. Now an internal leisure park.

When the old cinema closed the building was, for a short time, 'Pine World' and you could walk through the auditorium choosing your bedroom or dining room furniture in the pit and on the stage with the backdrop of the screen, which was for some reason left in its position as if someone expected films to be shown there again.

In the heyday of cinema Kingston had the Odeon, the Elite (where Wilko now stands), the Granada (now Pryzm), the Regal and Kingston Picture Theatre which evolved (or deteriorated) into the Studio 7. In the early 1990s there was just the Granada, which had been converted into a triple-screen theatre. There was then a shift in public attitude and cinema became popular again. Whether this was due to better films, which led to the demand for better cinemas or vice versa, is debatable but whichever the instigator there was a perceived need to cater for more cinemagoers in Kingston, and Clearwater Estates had their eyes wide open.

In 1996, Bentall's wanted to sell its Depository. Clearwater was successful in acquiring the building and then negotiated with both English Heritage and owners of neighbouring properties. They purchased Pine World and the old Kingston 'omnibus' station alongside and created a 'leisure park' with fourteen cinemas, a sixteen-lane bowling alley, amusement arcade, pool tables, restaurants, bars and a health club. The Depository was elegantly restored and remains a landmark alongside another, the curved-glass tower which gives the building its name. For films, food, fun and/or fitness, go to the Rotunda.

50. The Rose Theatre (2002–08)

Everyone needs a little bit of culture in their lives or at least the opportunity to go to the theatre and this was the one thing that Kingston lacked, with residents having to venture to Richmond, Wimbledon, Epsom or Woking. In 1996 the council was committed to having a theatre in town and, when St George expressed an interest in the Charter Quay area redevelopment, the provision of a theatre was on the drawing board from the start.

Design and planning issues resulted in the end of the century approaching and led to the theatre being billed as Britain's first theatre of the new millennium. Work started in 2001 and by 2002 the shell was ready and the first play, *Henry V*, was performed.

The design is based on the original Elizabethan Rose theatre and just as they had done 400 or so years before, audiences had to wrap up to keep warm as the theatre was not complete and additional funding was required (despite it already costing £2.3 million). In 2006, Kingston Council invested £6 million so that the fit-out could progress and the theatre finally opened on 16 January 2008.[89]

The design of the theatre is true to the old having a semicircular auditorium and the groundlings pit, where the audience can sit on cushions, harking back to the standing area in front of the old Shakespearean theatre stages. The theatre seats around 900.

Ironically, with the talk of film and TV taking audiences away from the theatre, the Rose stands on the site of the old Odeon cinema, which closed in 1967 only to be reopened as a bingo hall, which closed in 1988. Continuing the irony, the Odeon stood next door to Muybridge's place of birth.

The Rose Theatre.

That then is Kingston upon Thames in fifty buildings. Go and meet them and become friends.

References and Bibliography

1. *The Natural History and Antiquities of the County of Surrey* (Vol. 1), J. Aubrey (p. 45)
2. *Annals*, Stow, 1615 (p. 620)
3. *Kingston's Past Rediscovered*, J. Wakeford (p. 11, ref. 13)
4. *The Natural History and Antiquities of the County of Surrey* (Vol. 1), J. Aubrey (p. 46)
5. Old Kingston, G. Ayliffe (p. 62)
6. *The London Encyclopaedia*, 1983, C. Hibbert, B. Weinreb, J. Keay (p. 516)
7. Calendar of the Patent rolls Edward I. 1281–92 (p. 334) and 1292–1301 (p. 397)
8. Ibid. 1292–1301 (p. 510) and 1301–07 (pp. 293–94)
9. *The History of the Free Chapel of St Mary Magdalene*, Maj. A. Heales (p. 148)
10. Calendar of the Patent rolls Edward II 1307–1313 (p. 162)
11. Calendar of the Patent rolls Edward III 1350–1354 (pp. 362–63 and 435)
12. *The History of the Free Chapel of St Mary Magdalene*, Maj. A. Heales (p. 197,198)
13. Taking a peek behind the wall (*Surrey Comet*, June 14 2013), J. Sampson
14. http://www.english-heritage.org.uk/visit/places/coombe-conduit/history/
15. *Coombe Hill Conduit Houses and the Water Supply System of Hampton Court Palace*, J. W. Lindus Forge
16. *Kingston Past*, J. Sampson (p. 52)
17. *Kingston and Surbiton Old and New*, J. Sampson (p. 7)
18. *Kingston-upon-Thames and Surbiton in 1891– Illustrated, Commercial, Descriptive –* R. A. Harris (p. 57)
19. *Kingston Past* – J. Sampson (p. 65)
20. *Hidden Kingston* – J. Sampson (p. 10)
21. Ibid. (p. 11)
22. Kingston upon Thames Leaflet, The Kingston upon Thames Society (Item 4)
23. *Hidden Kingston*, J. Sampson (p. 12)
24. http://www.ledburyhistorysociety.co.uk and search for Burgage plots.
25. *Kingston's Past Rediscovered*, J. Wakeford (p. 50)
26. *Coroners' Inquests Violent, Unnatural or Suspicious Deaths in Kingston upon Thames and Surroundings 1700-1750*, J. Pink (p. 38)
27. *Pubs, Inns and Taverns of Kingston*, R. F. Holmes (p. 45)
28. *Pubs, Inns and Taverns of Kingston*, R. F. Holmes (p. 78)
29. *Kingston's Past Rediscovered*, J. Wakeford (pp. 52–54)
30. https://www.nationalarchives.gov.uk/currency/results.asp#mid and http://www.thisismoney.co.uk/money/bills/article-1633409/Historic-inflation-calculator-value-money-changed-1900.html
31. *The History and Antiquities of the Ancient and Royal Town of Kingston-upon-Thames*, W. Biden (pp. 71–90)
32. *Pubs, Inns and Taverns of Kingston*, R. F. Holmes (p. 20)

33. *Old Kingston*, G. Ayliffe (pp. 58 and 64)
34. *Picton House*, J. Allen (et al) (p. 24)
35. http://yba.llgc.org.uk/en/s-PHIL-PIC-1491.html Dictionary of Welsh Biography Philipps family of Picton, Pembrokeshire.
36. http://welshjournals.llgc.org.uk/browse/viewpage/llgc-id:1277425/llgc-id:1286388/llgc-id:1286442/getText
37. Ibid.
38. https://historicengland.org.uk/listing/the-list/list-entry/1080069
39. Horace Walpole Letters ix 157 and Boswell's Life Of Johnson Volume 5 (p. 314 'The training of gentlemen's daughters')
40. *That Famous Place*, S. Butters (pp. 108 and 127)
41. Contemporary advert
42. *The Kingston Bank -The early History of Westminster Bank Limited in Kingston-upon-Thames* (Issued 1956) (p. 5)
43. First Annual report of the proceedings of the Association for bettering the condition and morals of the poor in the town and neighbourhood of Kingston-upon-Thames (p. 9)
44. Ibid. (p. 15)
45. *New Monthly Magazine*, No. 61, 1 February 1819, Vol XI (p. 93)
46. *Half a Century of Kingston History*, F. S. Merryweather (p. 90)
47. *The History of Surrey*, Vol III Part 1, E. W. Brayley (p. 48)
48. Ibid.
49. *Kingston Then and Now*, M. Bellars (p. 11)
50. *The Journal of Southampton Local History Forum*, No. 17, Autumn 2010 (pp. 15/16)
51. *St Raphael's Catholic Church – A Brief History and Guide* (Church Guide)(p. 6)
52. Christ Church (St Albans) – The Beginnings – An early account 1850s–1943 – Revd John Waddington Hubbard and his church wardens.
53. Village London Part 4- South West – E Walford (p. 315)
54. *Tommy This an' Tommy That*, A. Murrison (Chapter 8)
55. *The Sporting Magazine*, May 1830 (p. 33)
56. Ibid.
57. Ibid, June 1830 (pp. 109–10)
58. *Recollections of Policing in Kingston upon Thames*, J. Pink (p. 3–4)
59. *Foul Deeds in Richmond and Kingston*, J. Oates. (p.74)
60. http://www.surreycomet.co.uk/junesampson/518355.June_Sampson—New_infirmary_as_Luck_would_have_it/
61. *The Kingston Book* – J. Sampson (p. 81–82)
62. *Kingston upon Thames – A Dictionary of Local History* (p. 46)
63. *Half a Century of Kingston History*, F. S. Merryweather (p. 79)
64. Ibid.
65. *The Kingston Book*, J. Sampson (p. 69)
66. *The Book World – Selling and Distributing British Literature 1900–1940*, Edited by N. Wilson (pp. 153–61)
67. *A Brief History of County Hall*, S.C.C. Archivist, D. Robinson.
68. Ibid.
69. *The Kingston Book*, J. Sampson (p. 116)
70. *Kingston Past*, J. Sampson (pp. 115–16)

71. Ibid. (p. 116)
72. *Kingston-upon-Thames and Surbiton in 1891– Illustrated, Commercial, Descriptive*, R. A. Harris (p. 29)
73. *Hidden Kingston*, J. Sampson (pp. 3–7)
74. http://britishpostofficearchitects.weebly.com/architects-r.html (J Rutherford)
75. *Village London Part 4 – South West*, E. Walford (p. 309)
76. *Kingston Then and Now*, M. Bellars (p. 3)
77. *Surrey Comet*, 14/6/91 (p. 8)
78. *Designed and Built in Kingston*, Kingston Aviation Centenary Project Leaflet
79. http://www.arthurlloyd.co.uk/Kingston.htm#palace
80. *My Store of Memories*, R. Bentall (p. 115)
81. Ibid. (p. 121)
82. Ibid. (p. 24)
83. http://www.theregister.co.uk/2014/10/24/geeks_guide_sopwith/?page=1
84. *A Century of Kingston upon Thames*, T. Everson (p. 65)
85. *My Store of Memories*, R. Bentall (pp. 144–45)
86. Ibid.
87. A treatise on the Railway & canal traffic act, 1854: and on the law of carriers as thereby affected, G. Brown (Appendix pp. xxii–xxvi)
88. http://www.johnlewismemorystore.org.uk/ (Kingston Introduction), J. Blatchford
89. *That Famous Place*, S. Butters (p. 464)

Acknowledgements

If you have got to here then you deserve the first acknowledgement, so many thanks for reading the book. I really hope that you will now look at the buildings in a different way and if you now feel 'attached' to any particular buildings please don't stop here. There are many stories and anecdotes that I have found but have had to leave out which are waiting for you to find them just as I have.

No historical work of any form can progress without reference to those who have set the path and we are all indebted to them for their works. The bibliography and references acknowledge works of such parties.

Since research today often requires use of the World Wide Web, I feel that Tim Berners-Lee deserves acknowledgement.

I would like to thank Louise Wood of PR & Marketing at John Lewis, Kingston, for sending me a sheet of construction facts.

I would like to thank my wife Carys, for her love, assistance, support and apparently inexhaustible patience during the preparation of this book.

Thanks also to my parents, Joan and Terry, for their love and inspiration. I am indebted to them for their interest in family and local history and for their active and enquiring minds.

Thanks to Lyall and Luke for being two sons who make a dad feel so proud to say they are his and also for Lyall's invaluable help with improving the quality of the photos.

All colour photos are my own.

There are a few image reproductions in this book. Endeavours to locate any copyright owner have not succeeded and the use of such images is on the basis and belief that the copyright has expired. A sincere apology if this is not the case.